Capturing the Magic of Children in Your Paintings

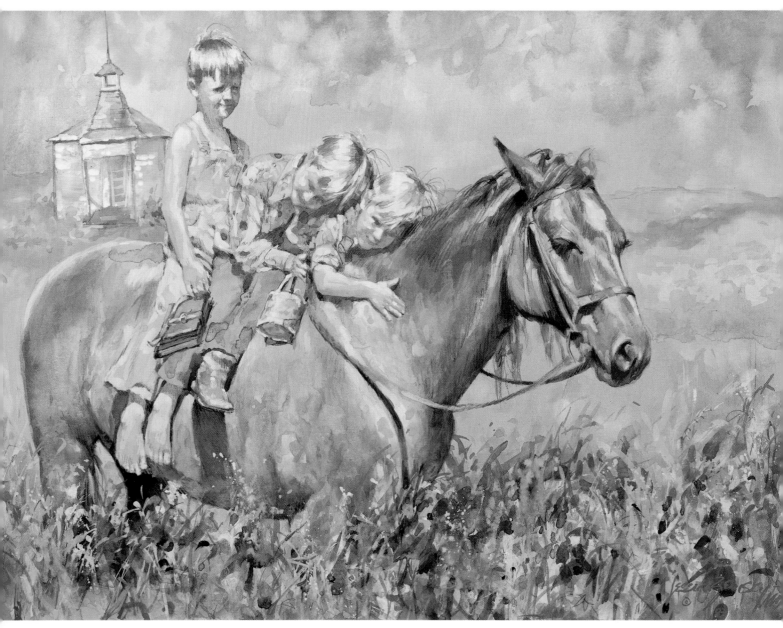

SCHOOL BUS, gouache, 20" × 24".

Sometimes unexpected things will trigger a painting idea. These ranch kids pile up on a horse anytime they feel like it. So I added an old school that I love so much, and realizing that kids used to ride to that school, just tied the two different time periods together for this painting.

Capturing the Magic of Children in Your Paintings

JESSICA ZEMSKY

NORTH LIGHT BOOKS
CINCINNATI, OHIO

Dedication

To all my kids—real and acquired. For all the fun they have given me and all they have taught me. And to my husband, the biggest kid of all.

ABOUT THE AUTHOR

Jessica Zemsky moved to Montana from New York in 1971. She shares her cabin studio in the Beartooth Mountains with Jack Hines, her husband and fellow artist. Jessica and Jack are founding members of the Northwestern Rendezvous Group and run the Pro Arte workshops. (For more information about Pro Arte and the Pro Arte workshops, contact Jessica and Jack at P.O. Box 1043, Big Timber, Montana 59011.) Jessica is a member of the Pastel Society of America.

Capturing the Magic of Children in Your Paintings. Copyright © 1996 by Jessica Zemsky. Printed and bound in China. All rights reserved. No part of this book may be reproduced in any form or by any electronic or mechanical means including information storage and retrieval systems without permission in writing from the publisher, except by a reviewer, who may quote brief passages in a review. Published by North Light Books, an imprint of F&W Publications, Inc., 1507 Dana Avenue, Cincinnati, Ohio 45207. (800) 289-0963. First edition.

Other fine North Light Books are available from your local bookstore, art supply store or direct from the publisher.

00 99 98 97 96 5 4 3 2 1

Library of Congress Cataloging-in-Publication Data

Zemsky, Jessica
 Capturing the magic of children in your paintings / by Jessica Zemsky.
 p. cm.
 Includes index.
 ISBN 0-89134-590-6 (hc : alk. paper)
 1. Children in art. 2. Art—Technique. I. Title.
N7640.Z46 1996
751.4—dc20 96-13913
 CIP

Edited by Pam Seyring
Designed by Sandy Conopeotis Kent

North Light Books are available for sales promotions, premiums and fund-raising use. Special editions or book excerpts can also be created to specification. For details contact: Special Sales Manager, F&W Publications, 1507 Dana Avenue, Cincinnati, Ohio 45207.

METRIC CONVERSION CHART

TO CONVERT	TO	MULTIPLY BY
Inches	Centimeters	2.54
Centimeters	Inches	0.4
Feet	Centimeters	30.5
Centimeters	Feet	0.03
Yards	Meters	0.9
Meters	Yards	1.1
Sq. Inches	Sq. Centimeters	6.45
Sq. Centimeters	Sq. Inches	0.16
Sq. Feet	Sq. Meters	0.09
Sq. Meters	Sq. Feet	10.8
Sq. Yards	Sq. Meters	0.8
Sq. Meters	Sq. Yards	1.2
Pounds	Kilograms	0.45
Kilograms	Pounds	2.2
Ounces	Grams	28.4
Grams	Ounces	0.04

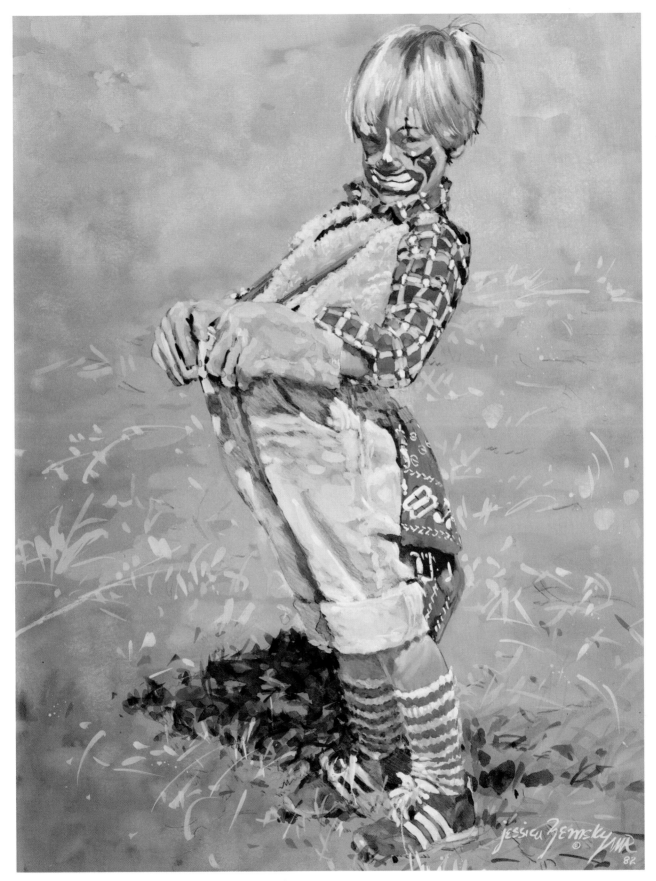

RODEO CLOWN, gouache, 24″ × 20″.
Collection of the artist.

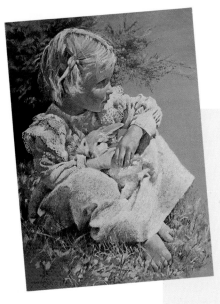

TABLE OF CONTENTS

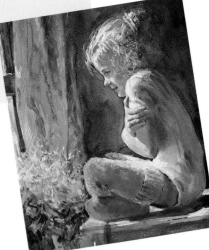

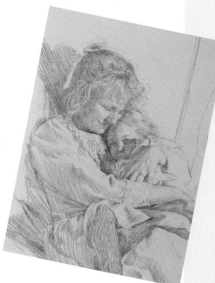

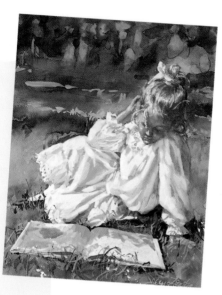

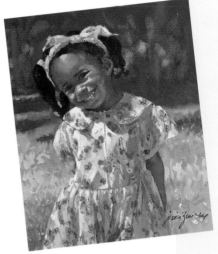

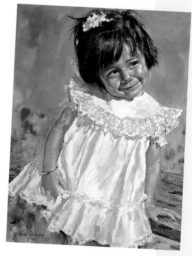

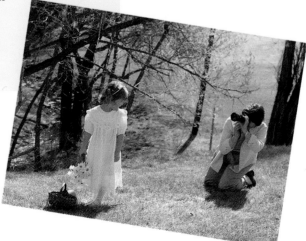

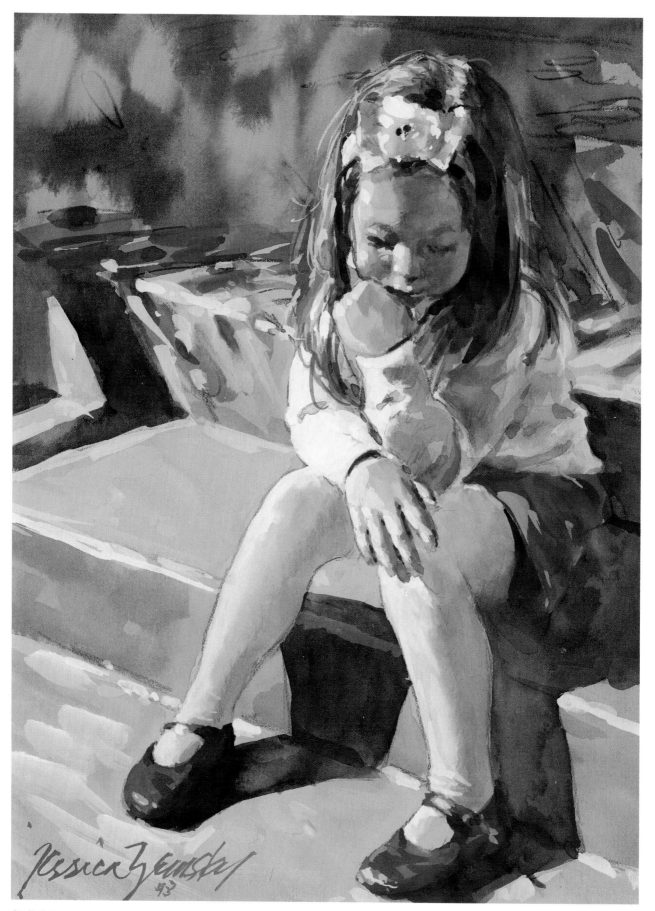

OH THE THINKS I CAN THINK, gouache, 12"×9". Collection of Mr. and Mrs. Peter Aronow.

INTRODUCTION

The Joys of Painting Children

Children are the most gratifying and aggravating of all subjects. Their whims can be fun, but full of surprises and pitfalls. Anything can happen, and it usually does. For example, your subject may show up looking entirely different than expected: new hairdo, glasses, missing teeth, etc. Such twists and turns keep everything fresh and interesting, so roll with the punches. Children are full of life and always changing. That is what makes them such a joy to be involved with. You never know what will happen, and that's a treat.

While still life and landscape have their challenges, they don't seem to create anecdotes the same way that children do. I have so many stories about painting kids. Throughout this book I'll share some of the funny, touching and revealing things I've learned about children: their quirks, behavior patterns, general attitudes, curiosity and downright joy. I'll help you develop the ability to capture their special personality differences to get at the heart of your models, so that your paintings will not only look, but also "feel," like the sitters.

All kids have unique personalities that must be picked up on to achieve good results in your paintings. Let them get comfortable, be natural, and talk about themselves. Try to get their points of view so that they can be happy while they are working with you. What do they think about the whole deal? Relax and enjoy the process. The children you work with will pick up on your attitude, and when it's all finished, you'll have developed lifelong personal relationships with your models and their families. That's hard to achieve with a grove of trees or a bunch of bananas. I don't think landscape artists are invited to as many graduation parties as I've been to.

This book expresses my attitude toward art and life, which is much like the way I cook: no real measuring, but lots of experimenting, tasting and going with the flow.

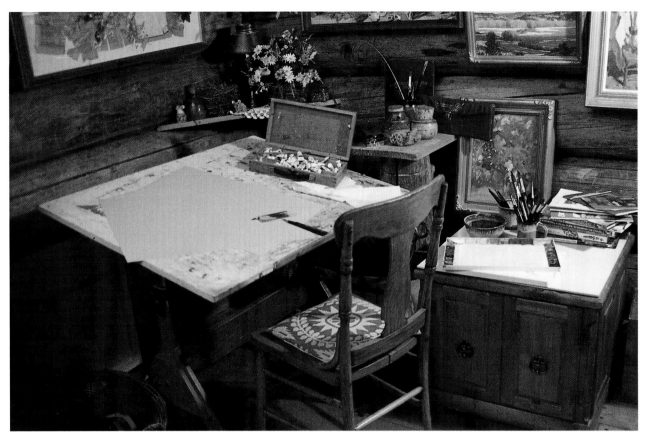

My work space

Your Working Setup

Find a spot in which to work, even if it's only a corner of a room. Keep painting stuff ready for whenever you feel like working, planning or daydreaming. You need to decide on an arrangement that includes good lighting (natural or fluorescent); a steady work surface, such as an adjustable drafting table or easel; a comfortable chair or stool (unless you prefer to stand while you work); and a table or chest to hold drawing tools, brushes, palette, water jars and photos of your kids. Comfort is part of the deal. Do you want music? A special cushion? Remember, you're going to spend many hours in this setup.

Painting Surfaces

Experiment with lots of different painting and drawing surfaces. I prefer a toned paper, as close as possible to the skin tone of my subject, for all my figurative drawing work. If you prefer a white surface, as I do for location painting, try hot-press (smooth) watercolor paper, rather than rough. Trying many surfaces will help you discover what works best for you.

Hint

Make sure your coffee mug and paint water jars are far apart.

Paper-stretching procedure: soak, flatten, tape and staple.

Sharpen pencils with a razor blade. Fine-tune the point on a sandpaper block.

My palette

I use Pro Arte brushes for all my painting. They're stupendous—great and cheap.

Stretching Paper

I stretch all my papers before painting, but after completing preliminary drawings. You'll need butcher's tape (the kind with water-activated glue on it—like that used on stamps), paper towels, water and a staple gun. Fill a large tub with enough tepid water to cover the paper. Soak the paper in the water for five to eight minutes, poking it down from time to time to make sure it gets evenly wet. Let it partially drip dry (until it stops dripping). Flatten it out on a wooden drawing board, pressing down firmly, and tape the edges down. Staple all around the edges. Let the paper air dry flat. Do not remove from board until painting is finished.

Pencils

I'm really hooked on colored pencils in a variety of browns, rather than black graphite. They put down a softer tone that blends just marvelously with paints, and they don't bleed. But they don't erase easily either, so use graphite pencils until you feel really sure of your drawing.

Sharpen your pencils to stiletto points using a single-edged razor blade and sandpaper block. Pencil sharpeners make dinky little points that get used up too fast. The longer the point, the longer you can draw without having to stop and sharpen. Also, try to sharpen about a half dozen pencils before you start your drawing—to have at the ready.

Palette

My palette has little wells that separate the colors, as well as a cover, in case I want to take it somewhere. A white enameled porcelain butcher's tray (available through art suppliers and traditionally used for mixing water mediums) is also useful for spreading out acrylic paints. It allows you to make big puddles of color, and provides easy clean up—vital with acrylics, which dry out quickly and need constant replacement.

Brushes

I use round brushes with good points for water mediums, from a no. 5 all the way to a Pro Arte no. 24. Using a ragged, frayed brush is like trying to slice an angel food cake with the side of your hand, so forget junky supplies. You're an artist, and you can't work well with bad tools. Use the best (but not necessarily the most expensive) brushes you can lay your hands on. I use Pro Arte brushes for all mediums. They're great—and cheap.

11

Pigments

If you choose to paint with gouache, watercolor, acrylic or oil, start with about twenty colors. Try whatever you like and make your own evaluations. The color names I've given you on the chart at right are Winsor & Newton gouaches, but most kinds of paint come under the same or similar names.

If you choose to work with pastels, start with a set of several hundred sticks. You need many dozens of colors and shades, because pastels produce exactly what the stick shows.

OILS

Here is a typical oil palette. I used these colors for *Lauren's Garden* (below and page 47).

- Lemon Yellow
- Yellow Ochre
- Cadmium Yellow Hue
- Raw Sienna
- Cadmium Orange
- Cobalt Violet
- Alizarin Crimson
- Cadmium Red
- Naples Yellow
- Viridian
- Cerulean Blue
- Thalo Blue
- Permanent Rose
- Terre Verte
- Ultra Violet
- Thalo Red Rose

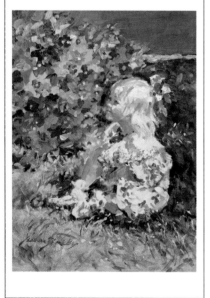

ACRYLICS

Here is a typical acrylic palette. These colors were used for *Montana Autumn* (below and page 33).

- Cadmium Yellow Light
- Cadmium Yellow Medium
- Turner's Yellow
- Grumbacher Hansa Orange
- Grumbacher Red
- Cadmium Red Light
- Naphthol Crimson
- Acra Violet
- Medium Magenta
- Raw Sienna
- Prism Violet
- Brilliant Purple
- Cerulean Blue
- Cobalt Blue
- Hooker's Green
- Jo Sonja's Brilliant Green
- Pine Green
- Ultramarine Blue

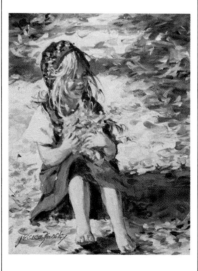

WATERCOLORS

Here is a typical watercolor palette. These colors are used in the paintings *Christine and Raggedy Ann* (page 21) and *Waiting for the Watermelon* (below and page 25):

- Lemon Yellow
- Cadmium Yellow
- Naples Yellow
- Cadmium Yellow Medium
- Cadmium Orange
- French Ultramarine
- Cobalt Blue
- Manganese Blue
- Yellow Ochre
- Scarlet Lake
- Cadmium Red
- Viridian
- White
- Carmine
- Rose Carthame
- Cobalt Violet
- Light Red

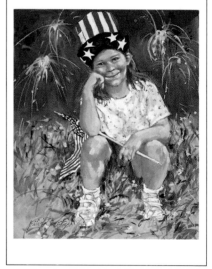

Permanent or Zinc White
You should have a lot more white on hand than any other color.

Lemon Yellow
Cool yellow

Cadmium Yellow Pale
Warmer yellow

Golden Yellow or Brilliant Yellow
Warmest yellow

Cadmium Orange

Yellow Ochre

Alizarin Crimson, Geranium or Grenadine
Cool red

Parma Violet or Light Purple
Any purple you like

Cerulean Blue or Sky Blue

Azure Blue

Periwinkle Blue

Winsor Blue
Many artists use Cobalt Blue, but it does not reproduce well in print.

Permanent Green Middle or Permanent Green Light

Oxide of Chromium
A gorgeous silvery green

Viridian
Viridian has a tendency to dry out quickly and crumble on your palette—keep it moist if you can.

Carthamus Pink
A little goes a long way, because it's a brilliant color and it does bleed.

Naples Yellow
Your flesh tones will never go chalky if you use Naples Yellow instead of white for a base.

Chinese Orange
I use Chinese Orange in combination with purple for rich shadows on flesh tones.

Bengal Rose or Rose Tyrien
Another gorgeous pink

Spectrum Red or Cadmium Red Pale

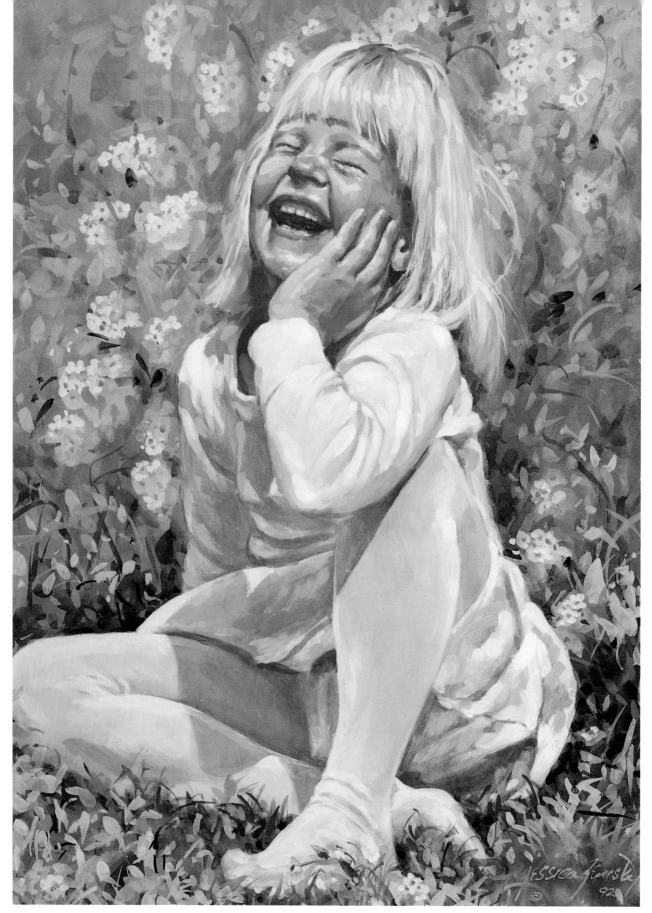

HAPPY DAYS, gouache and pastel, 20" × 16". Private collection.

Magic in All Mediums

All the art mediums discussed in this book have related qualities and unique characteristics—as do all artists. Try all the mediums, then pick the ones you like the best. It's up to you to discover for yourself which really say "hello" to you. Watercolor is wonderful, beautiful, fast and exciting. Acrylic is a great medium because it dries so rapidly. Gouache, an opaque watercolor, is lovely for painting children. Oil is a highly respected medium; discover what it can do for you. Pastel is something else; what you see is what you get, with hundreds of marvelous colors right there! Try all of these mediums, and prepare yourself for a magic time!

The Right Pose

Before we get to painting, we really need to talk about what makes a good pose. I offer you the following checklist as a guide to your photo selecting.

- Use color prints, taking into consideration the warm and cool colors you'll use in your painting, not just the darks and lights.
- Use photos with good light to help you read forms and features.
- Use photos that show as much of the figures as you need, but try not to use photos with feet foremost or hands in odd positions, or shots of tiny figures with lots of background.
- Use photos that show place, season and time of day.
- Use photos in which the subjects look natural, capturing expressions, gestures and personalities.
- Use more than one photo and make modifications if necessary, making sure your proportions are right.

Joe's Girls was one of those pieces for which I had to rely on furnished shots. I did not actually know the children. I received a bunch of photos to work from, but some of the shots were no good at all.

Hint

Get good references, even if you need to use several photographs. Don't be lazy, or fudge anything, because of a lack of reference material. You'll be sorry when it comes to finishing a painting.

1 The background is in full sunlight, but the girls are in shadow. There is no light on the faces to help show form and expression. The subjects are not as appealing or revealing as they could be.

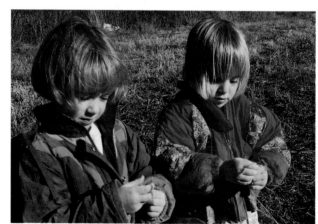

2 There are no eyes to work with in this shot, and the light behind the girls does nothing for their faces, which are all middle values.

3 There is some good light in this shot. It brings up cast shadows and shows form on the heads. That is great, but the girls are not relating to each other; and what are they doing?

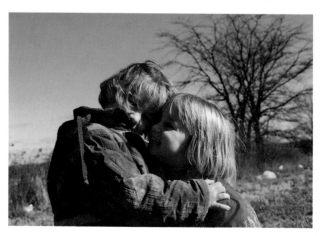

4 Here is a fine, loving gesture, but very little facial detail.

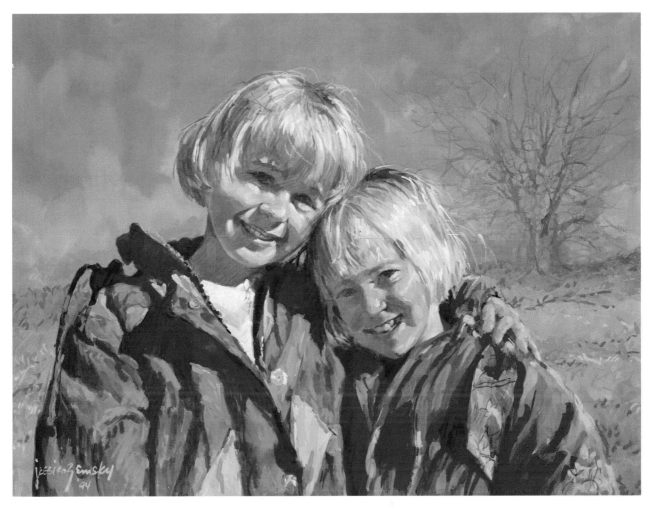

JOE'S GIRLS, gouache and pastel on paper,
20" × 24". Collection of Joe Wood.

A composition with the two figures placed centrally up front forms a natural horizontal. The tree suggests space, season and a sense of the place; its lacy effect is also an attractive contrast to the solidity of the girls, and gives the eye another place to look, keeping the piece from being too static.

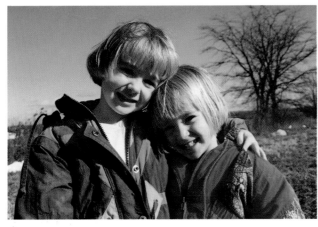

5 This is the one to go with. It has it all. Everything is right: simple sky; off-center tree; colorful winter jackets; expressions and gestures that show a beautiful, sisterly relationship; light from the side showing everything needed to paint from. The shadows are too strong on their faces, but that can be fixed. This one is the winner.

Hint

Pay some attention to the corners of your painting. Making each a different color, shape or value can enhance the composition, creating interest right out to the edges of your painting.

WATERCOLOR ON WHITE PAPER

Brushes are more important with watercolor than with any other medium, because the gesture of your strokes is vital. Pro Arte rounds hold oodles of water, and they always come back to a fine point. I mostly use round brushes, but some flats too, and smooth or rough watercolor paper. There are several methods of using watercolor:

• The English method is achieved by superimposing light washes of various colors over each other and letting them dry between each coat.
• The sewing-up method is achieved by leaving white paper between wet brushstrokes to prevent their running together. Blending is accomplished before drying, while hard edges are filled in after drying.
• The smooth paper method lets colors run together for blending, but requires care when they should be distinct.
• The dry-brush method requires very little water so that runs become less important, leaving less to chance.

All this information is from Eliot O'Hara, a well-known teacher. I was among the fortunate ones who studied with him at his school in Goose Rocks Beach, Maine.

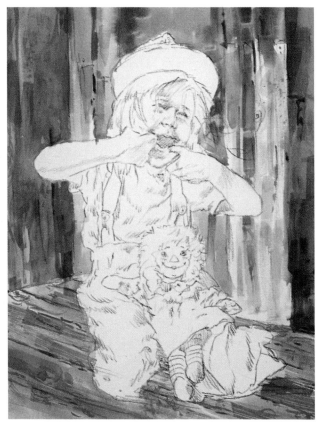

1 *Drawing*
Draw your composition simply on Strathmore bristol 3-ply paper, then stretch the drawing as described on page 11. Let it dry before beginning to paint.

2 *Lightest Washes*
You need to plan when doing a watercolor, especially for values. Start with lightest washes, strengthening your darker values as you go. Run a thin, cool wash behind the figure to subdue the white paper there. Keep the whites for Annie's dress and Christine's suit. Using rounds with lots of water, wash in the tabletop with orange and Yellow Ochre. Use a flat ⅝" series 204 Sterling for beginning the wood-grain effect.

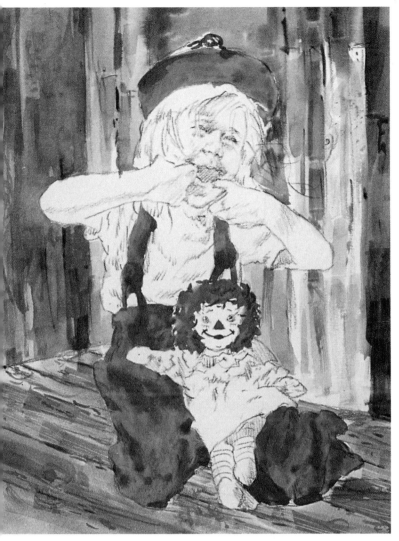

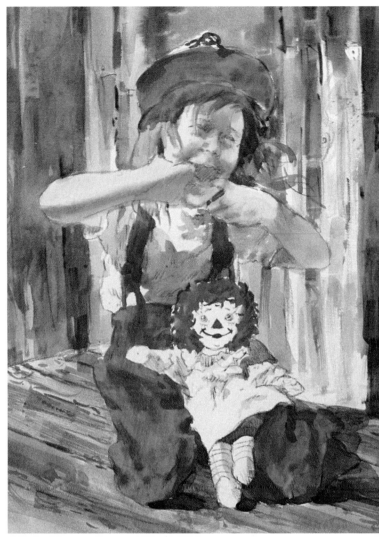

3 *Pink It Is*
Next run in some of the local colors of the outfit; in this case, the overalls. Pink is Christine's favorite color, so pink it is. Here's a trade secret: I run the watercolor red in with pink gouache because the watercolor pink just isn't what I want to get started.

4 *Value Structure*
There is a nice, strong definition of values in this subject. Working from light to dark, let the paper—in this case white—work for you. As a matter of fact, it's a fine idea to choose a subject that includes white areas, so that your paper can be your whites and contribute to your value structure. Work on the fleshtones using pure Naples Yellow for the lit side of the subject, and follow with washes for the hair. Because there is a lot of red and pink in the clothes, try to keep the shadows nice and warm under the cap, down the side of the face and arms, and on the shirt.

5 *Refinements*
Now you're pretty much in business. What remains is to paint the refinements and adjustments that make it all happen. Drips are one of my favorite things about watercolor, so leave as many as you feel comfortable with. Use limited colors to help create harmony in your picture. There are, of course, oodles of colors, but if you choose a few in each hue, you'll keep the piece from getting spotty. For example, use the same blue in the shadows of the shirt as in Annie's dress—with some modification, of course.

6 *Darken the Table*
Darken the wooden table using a big brush saturated with orange and purple.

Hint

Feel free to make adjustments as they seem necessary. When painting people, a good understanding of anatomy helps you make the correct adjustments from your photos to your picture.

7 Add Detail

The loose, watery background and wood table are pretty well finished. Very judiciously add detail starting at the top, clarifying hair, facial features, details of clothing and Annie. After cleaning your water and palette one last time, do any final, itsy-bitsy stuff. Then sign it!

CHRISTINE AND RAGGEDY ANN, watercolor, 30" × 24".

WATERCOLOR ON TONED PAPER

Use watercolor on toned paper? It's a pretty unusual approach, but such a lovely base. I do lots of plein air pieces (scenes painted outdoors directly from observation) this way. You will have to apply more pigment, but other than that there should be no problem.

1 *Beginning Drawing*

2 *Color and White*
This subject is so full of life and fun. Do the color first, establishing the feeling you want in the painting. The flesh colors are Naples Yellow, orange, Cadmium Red and then a wash of Cobalt Violet. Use watercolor white in your skin mixture to bring the light areas higher than the tone of the paper. Use Cobalt Blue and Alizarin Crimson with a Naples Yellow and orange mixture for the cool side colors. Let the paper come through as middle value. Then paint areas in with opaque white, making adjustments as necessary.

3 *More White Accents*
Lay in patterns of white. Notice how lovely the flesh-tones read with the white accents and the base color showing through.

4 *Local Color*
Paint the hair, shorts, hat, flag and shirt.

Hint

White and watercolor is a no-no with some purists, as you can lose the gorgeous transparency of that medium, but don't worry about a bit used here and there if needed. It's perfectly OK to use touches of opaque white for corrections or accents, especially if it results in a great painting.

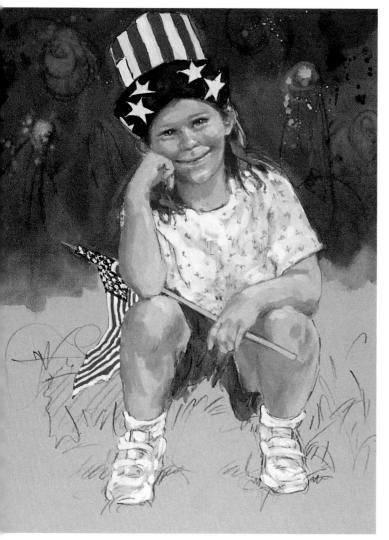

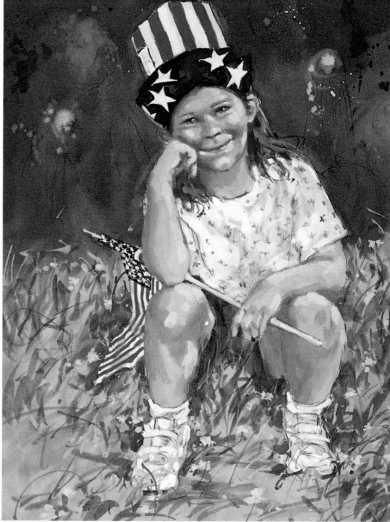

5 *Background*
Paint a dark, wet ground with an outdoor feeling for the sky with fireworks. Apply a mixture of Cobalt Blue and Cerulean Blue, Alizarin Crimson and a touch of white—over the wet ground. While still wet, apply thick yellows and blues to suggest fireworks.

6 *Grass and Figure*
Concentrate on building up the grasses; Sterling flats are great for putting in the yellows (including Naples Yellow) and greens of the foreground. They can be used wet or dragged as dry-brush (a method of painting with very little moisture). Work hints of sky color and opaque yellows into the existing grasses last; July 4th is dandelion time, so add some—they're such a happy color, and kids love them. Use everything but red, keeping that as a strong accent color. Now devote some more attention to that cute figure, keeping a very light touch when finishing her. Paint the skin highlights first, then the shadow side. Use white very judiciously, mixing it with local color.

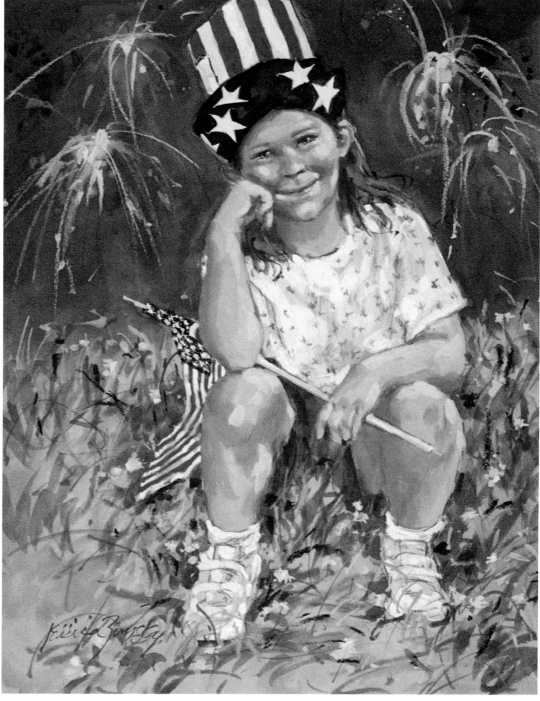

7 Last Look Time

You will not be able to get the fireworks brilliant enough with watercolor, so bring them up really bright using pastels.

WAITING FOR THE WATERMELON, watercolor on toned paper, 20" × 16".

THE GENTLE TOUCH, watercolor on toned paper, 20″ × 26″. Property of Shodair Hospital, Helena, Montana.

This is a typical example of watercolor. The loose washes and overall soft feeling convey the whole idea, which is to melt one color into another, with tiny touches of opaque for highlights.

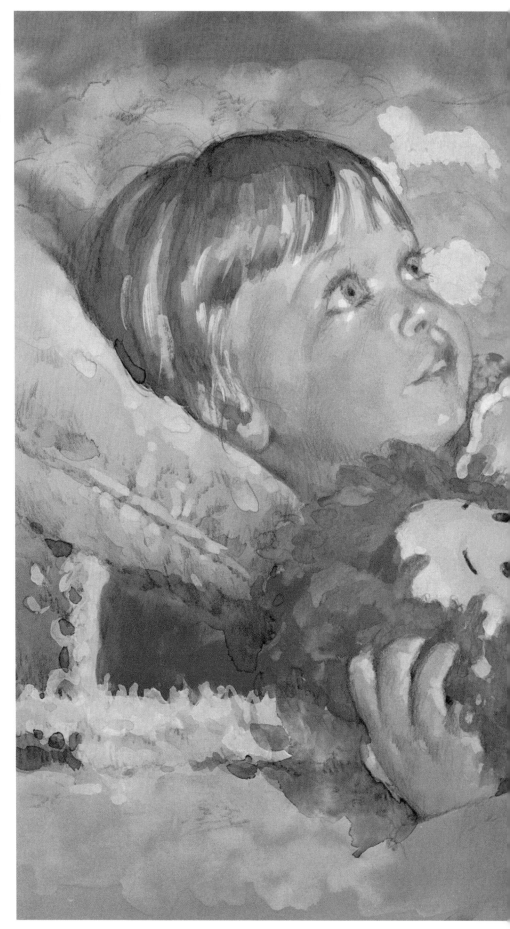

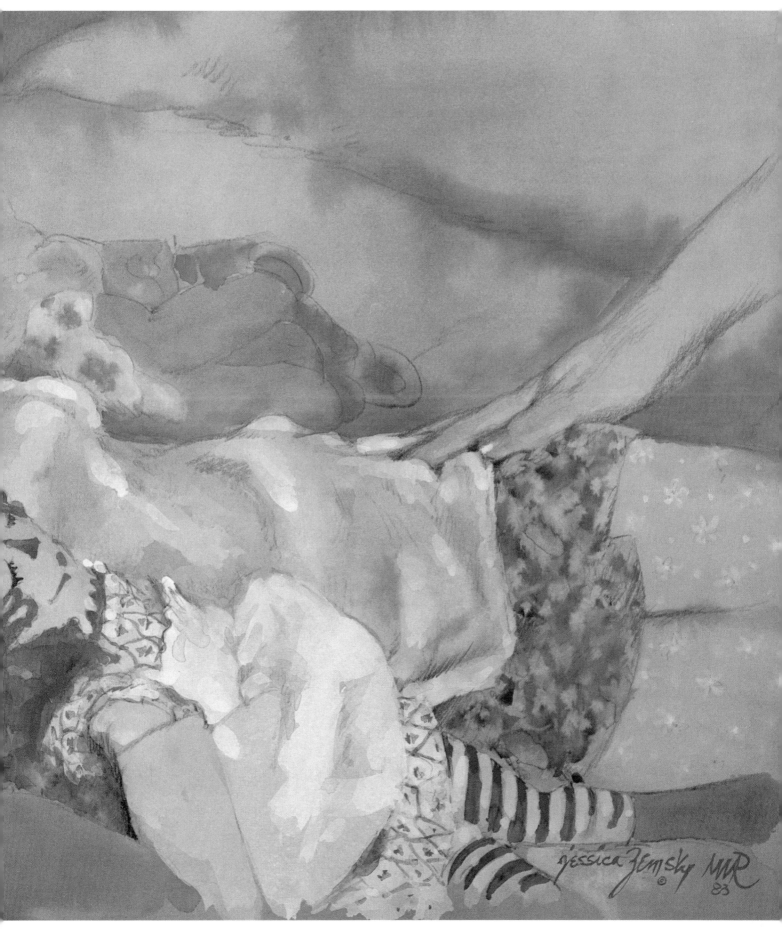

ACRYLIC

You can use acrylics thinly; directly out of the tube; with a brush or palette knife; on just about any surface. They dry very fast, and are available in many wild colors. Acrylics are permanent and need no spray fixative or protection from the sun. Once acrylic's down, you've got it—or it's got you. Acrylics are wonderful to experiment with. Do try them.

1 *Beginning Drawing*

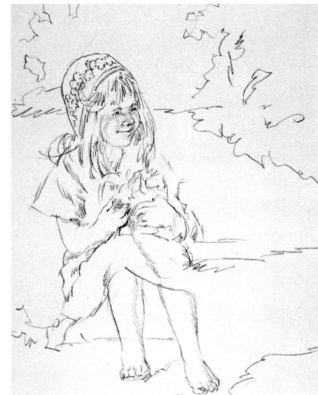

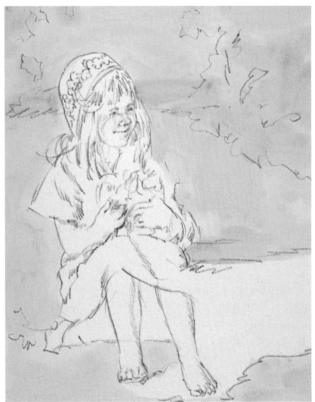

2 *Ground*
On a white surface, start with yellow and gold washes applied wet-over-wet to establish a ground against which to work. I really like Liquitex Turner's Yellow, which is close to Naples Yellow and works well for so many things. Yellow Ochre and white also work.

Hint

Acrylics, the newest members of the paint family, need a bit of special attention, like all young things. They require a little extra care in mixing, because if you blend too many colors together, it all quickly turns to gray. So pay attention.

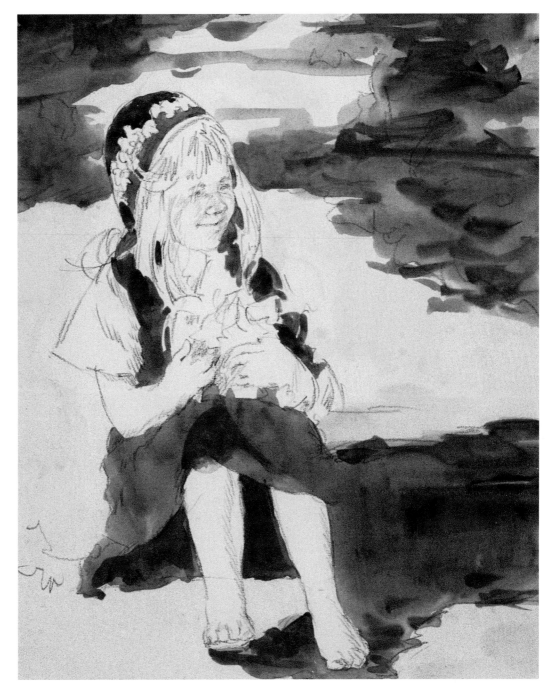

3 *Large Shapes*
Violet shadows; you can't get more color contrast than that. The large shapes will be useful later on, allowing you to work areas that have an established value. Deal briefly with every section except the subject.

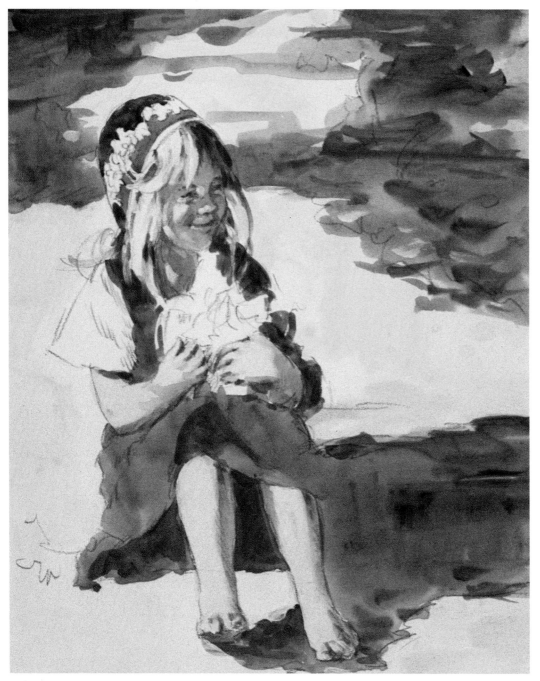

4 **Fleshtones**
Begin to concentrate on the figure with rosy, peachy and pink fleshtones, using mixtures of Liquitex Yellow Medium Azo, Grumbacher Red, Grumbacher Hansa Orange, Rembrandt Napthol Red Light and white.

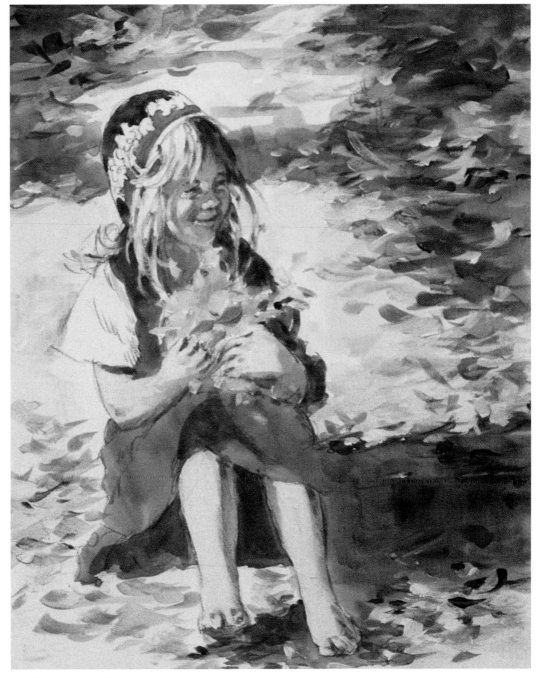

5 Dry Autumn Leaves
Using a Sterling ⅝-inch or 1-inch flat brush with a crisp stroke, rough in the dry autumn leaves with yellows, oranges, reds, ochres—every warm color you can find. Use some Chromium Green Oxide, Pine Green and muted greens too.

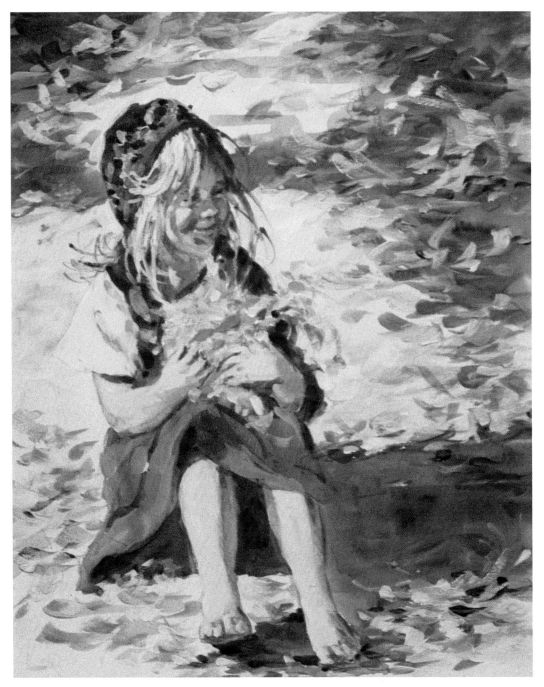

6 Adjustments and Details

The whole picture is important, but the main thing is the girl. Does she need more accents? More color? How are your edges? Take a serious look and make adjustments. Keep pushing values, making the lights lighter and the darks richer. Concentrate on the light source on everything. Work her blouse and costume. Use a palette knife to heighten the textures. Use reds straight from the tube, because any touch of white dulls them tremendously. Add some leaf detail, with swirling leaves in various positions and patterns.

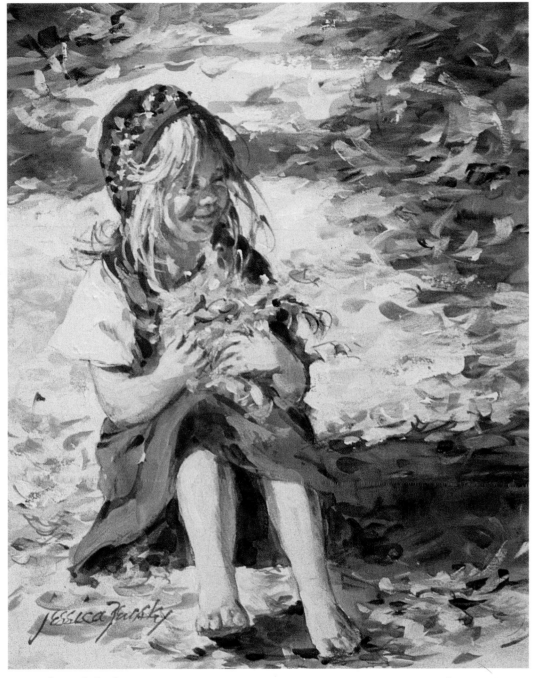

MONTANA AUTUMN, acrylic, 20" × 16".

7 Light and Shadow

Work more on the leaves, while focusing on strengthening light and shadow. Make use of reds and other colors to add a lot of interest to the painting. Keep playing with little bits of color until the painting really suits you. Then you're finished.

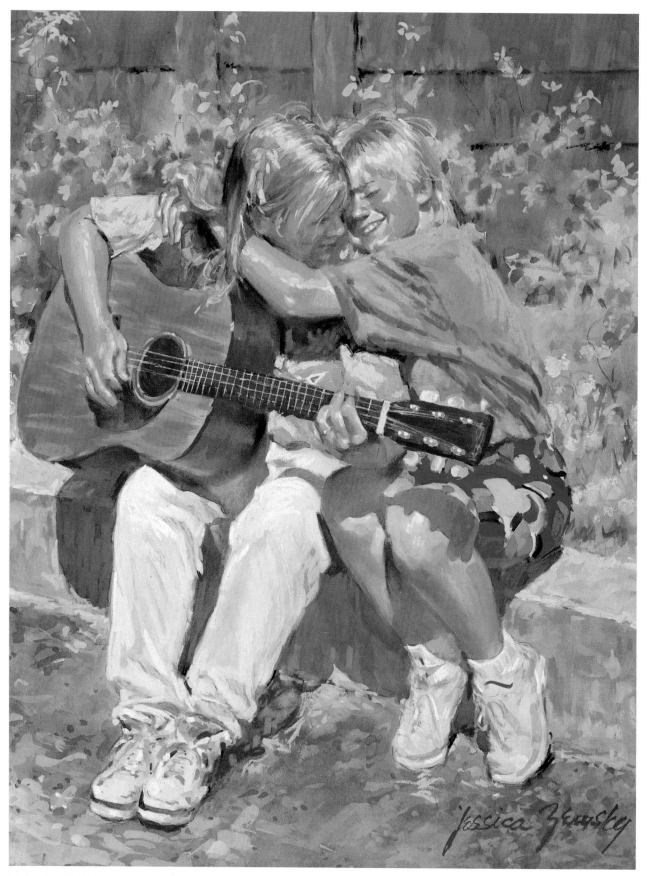

MOM I JUST LOVE THAT SONG, gouache and
pastel, 24" × 20". Collection of the artist.

GOUACHE

Whereas watercolor is unforgiving, gouache is suited to making repeated adjustments while providing gorgeous, opalescent color.

Gouache is, I suppose, my favorite of all. It has unique opaque qualities that let you go back into an area repeatedly for a desired effect, yet lends itself to the loose wash treatments so juicy and great for floral effects.

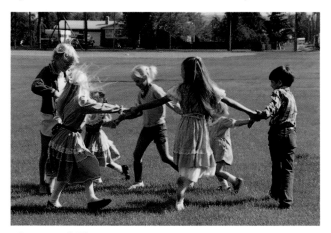

Come and Play

There is a natural joy and freedom in children at outdoor play. These kids are terrifically unposed. The mowed park lawn is all wrong, but that's easily fixed by adjusting the setting. Decide whether you want trees, or maybe just an open field of flowers, then hunt up some background references. For example, you could use some shots of a wooded area. Cottonwood trees in the background would be great. They are incredibly messy and wonderful—like the kids themselves! The Montana wind is blowing, so come on. Have some fun!

1 Planning Sketches
Horizontal format takes advantage of the spread-out action and overall feeling of the game. Pick and choose whichever figures you like, adjusting sizes, ages and clothes. Minimize features and expressions of each individual child for the overall effect of running and laughing.

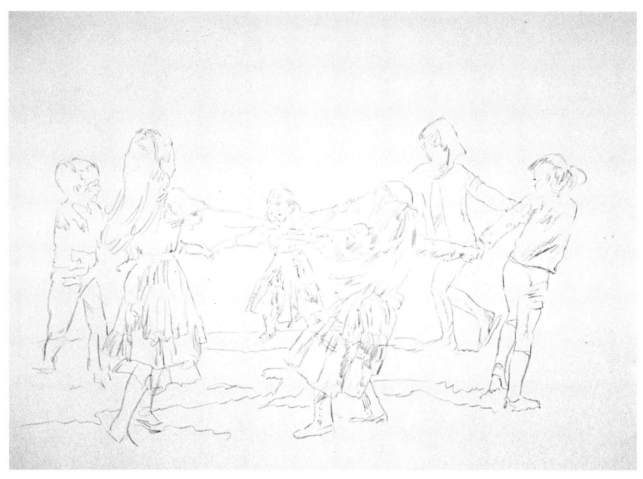

2 Initial Drawing

Select the size of the piece, then loosely draw in figures based on different poses for the arrangement you want, keeping in mind that you can adjust them for effect later. Space is what this painting is about: open fields choked with wildflowers pushing past each other; the figures suggesting an open, outstretched, reaching feeling, as well as breeze and speed. The ring is used as a very obvious symbol of the simple happiness and overall feeling of joy in the scene. Overlapping figures (such as the hidden child whose hands are all you see) happen in life, and so lend a sense of reality. Don't line up the figures like clothes hung out to dry. Leave something for the viewer's imagination. After you've done your initial drawing, stretch it as described on page 11.

3 *Color*
Color is as important as composition, so wash in both background and figures with a warm bath of Carthamus Pink, orange, and Bengal Rose, tying elements together with a unified color feeling. For grass, apply a band of Oxide of Chromium in the near foreground, and another of light green and white mixture behind it. Follow with an orange wash to accent the sunny side of the figures, making sure they all seem to exist in the same light.

Hint

The various water-based mediums are often interchangeable. Be adventurous; try different combinations. Keep track of the good ones; get rid of the awful ones.

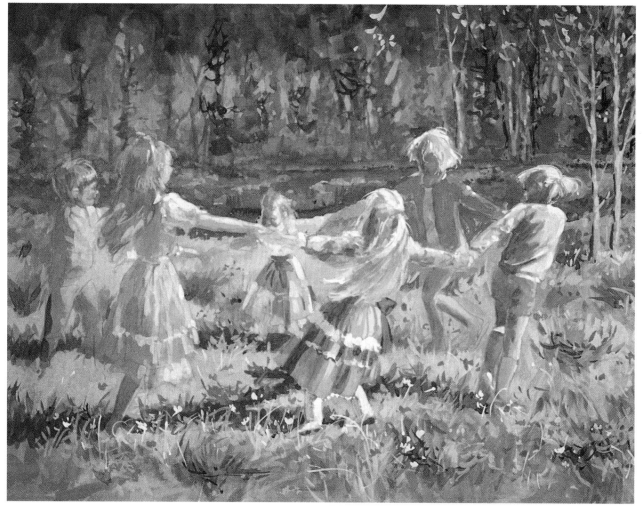

4 *Value*

Enrich the foliage with violet and green mixtures. Add flecks of sunlight on trees and leaves. The figures come next, with warm and cool lights, as well as bright darks, to create both color and value contrast. Add depth with cool blues and violets, more delineation of form, and sunlight flooding in strongly from the right.

Hint

It is your job to decide how completely stated you wish your painting to be. Do you want to portray specific children that we could recognize on the street, or just suggest a few forms? Should you carefully detail the clothes? Form the flowers and grasses with botanical correctness? Or are you satisfied with the impression of children enjoying the freedom of an experience in a flower-filled meadow? Perhaps you'll decide on a little of each!

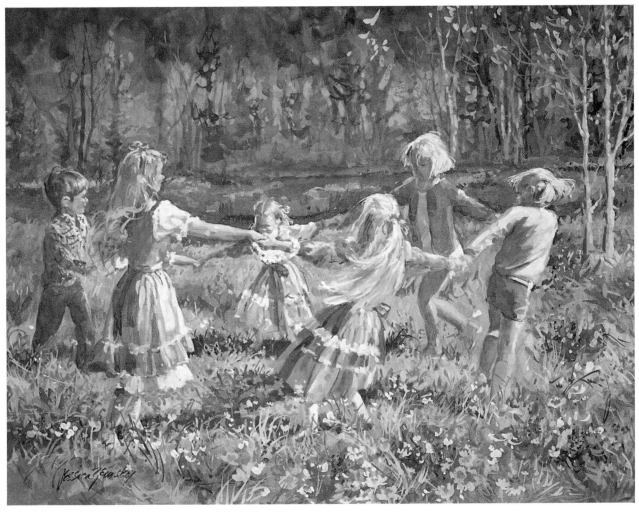

5 Variety of Details

Add bright orange lights through the muted trees at top, as well as highlights and darks on the figures. Get into the grass and flowers. Work over the entire piece with a natural-looking variety of sizes and gestures.

Hint
Suggest wildflowers that are found in the area you're trying to depict. Check with reference books, if necessary.

6 Create an Impression

Try to make it all feel lush, deep and affected by the breeze that dances through everything. Create the impression of a moment, leaving lots for the viewer to fill in. Suggest more detail than you actually paint in, going for the effect of color, life, freedom, fresh air and childhood.

RING AROUND A ROSIE, gouache, 26" × 30". Collection of Mr. and Mrs. Wheeler Daniels.

OIL

Oil paint is a marvelous medium. One of its great pluses is that it dries slowly; the paints just wait for you on the palette for a very long time. That lets you have fun messing around with them. I use the same types of colors for oil as for water mediums, with a butcher's tray palette and turpentine for thinning washes. Have lots of thinner on hand, as well as paper towels or rags to clean your brushes between mixing new colors.

Surfaces for oil painting include canvas, either cotton or linen, primed or unprimed. Most artists apply an initial primer coat of white gesso to close the pores of the canvas, because oil paint on unprimed canvas can do strange things. In the following demonstration, you'll be learning how to use paper with oils, although some papers are not suitable for the purpose.

Many stand-up painters favor long-handled brushes; short handles are better for those who sit while working. I love Pro Arte rounds, and rough hog hair bristles provide nice dragged effects if you pull the brush so it catches on the surface, leaving an uneven texture.

I used Strathmore 3-ply bristol surface paper for this demonstration. It's much simpler to prepare paper than canvas. Just tape down the corners of the paper to some kind of board and you're ready. I paint with Pro Arte Sterling flat brushes, series 201. They're terrific, and so pretty with their silver handles. See page 12 for my typical oil palette.

1 Drawing
Colored pencils are not suitable for doing an initial drawing for oil painting, because turpentine makes them run. Use a regular graphite pencil.

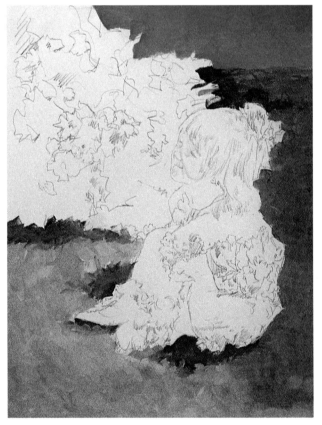

2 Overall Look
Apply very thin washes to start, establishing an overall look. Rough in some greens (mixtures of Lemon Yellow, Thalo Blue and Terre Verte) for the lawn and Thalo Blue for the sky. Spare out the figure of the child and the bank of flowers.

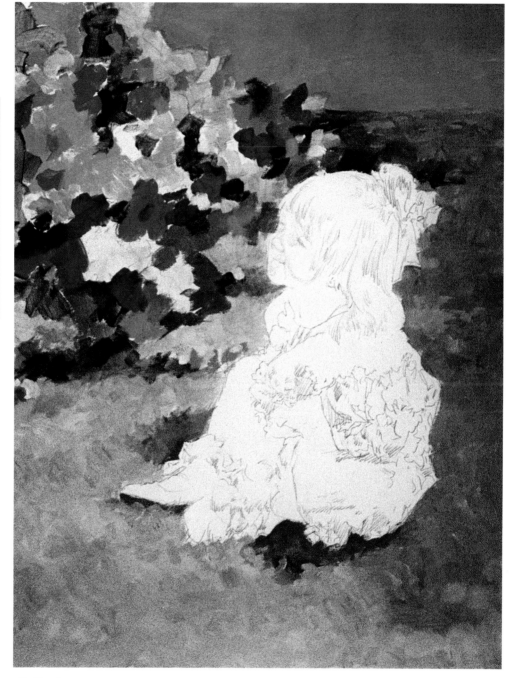

Hint

Keep looking, thinking and adjusting all through the painting process.

3 Setting

Begin to create the setting for your subject by painting the band of flowers in pinks, violets and Cadmium Reds, running greens through them and suggesting sky with Thalo Blue. Let the floral areas dry periodically as you go, so that you can play around with them without muddying up your color. Suggest a pattern of light colors in the floral section next to the figure, roughly covering the picture surface entirely. The girl will be very light in value, becoming the strongest, side-lit section in the piece, so doing the flowers now begins to create the proper values to enhance, not compete with, her.

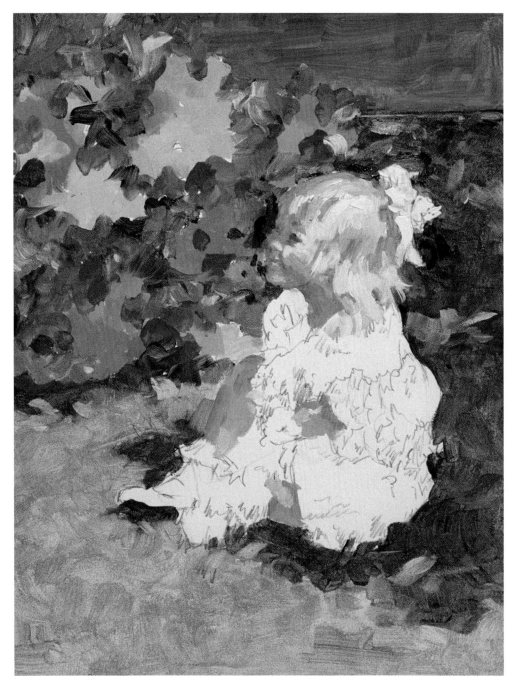

4 ***Figure***
Now do a bit of work on the figure. You want a fresh, light approach, so make sure your brushes are clean, your turpentine is fresh, and your flesh colors are pure. The light for this subject is coming from the right, throwing her face into shadow; make sure the shadow side has color and isn't just dark. Do the face and skin first. Then do the hair. Keep in mind that on a very young, fair-haired child, the skin and hair really blend together, with no noticeable hairline. Highlight the hair and the face.

Hint

Don't lay oil paint on thick too quickly. Apply washes at first, building up thickness as you go. I also recommend painting from the background forward. That usually has you working from the top down and keeps you from dragging your hand on a wet surface.

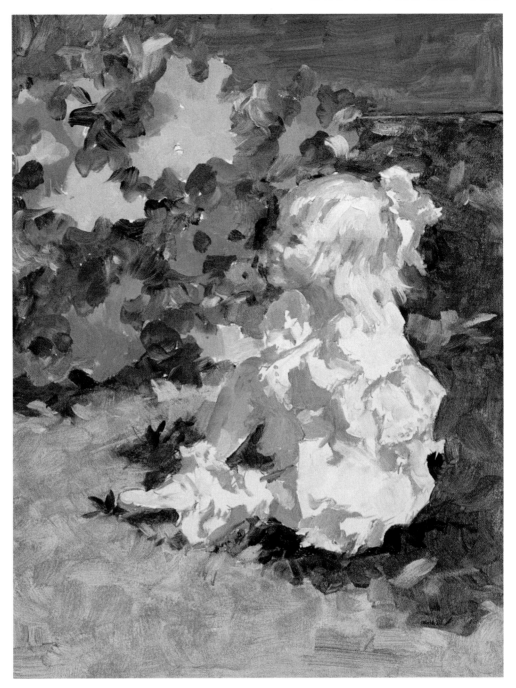

5 *Clothing*

Begin painting the dress, fancy socks and shoes with whites, working from there. Use Cobalt Blue with white for shadows because that color sets up an exciting dialogue with the Thalo Blue of the sky.

Hint

The finished work does not always need to be visualized in advance. Many pictures just grow! When is a particular painting finished? It's up to you!

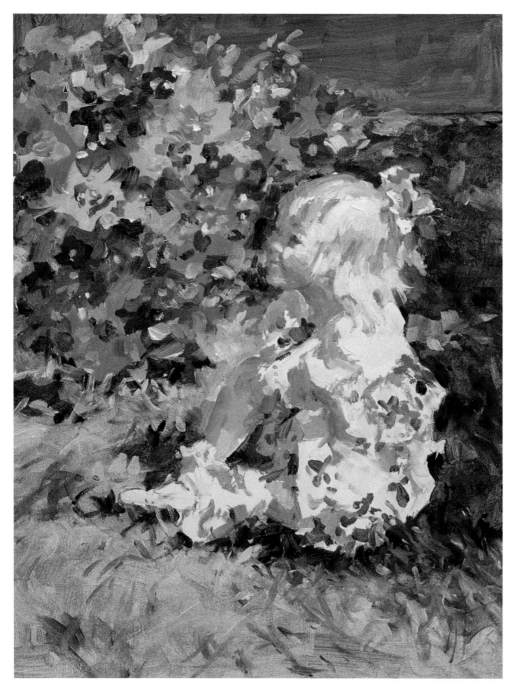

6 Details

Adjust the flower values down, killing the pure whites, so that the subject and her clothing look lighter in comparison. Pay some attention to detail in the flowers, leaves, dress pattern and hair bows.

Hint

Get rid of Mama when you're working. sweet and loving as she is, she's a distraction. she also fusses—combing hair, fixing ribbons, asking for smiles. You can do without that.

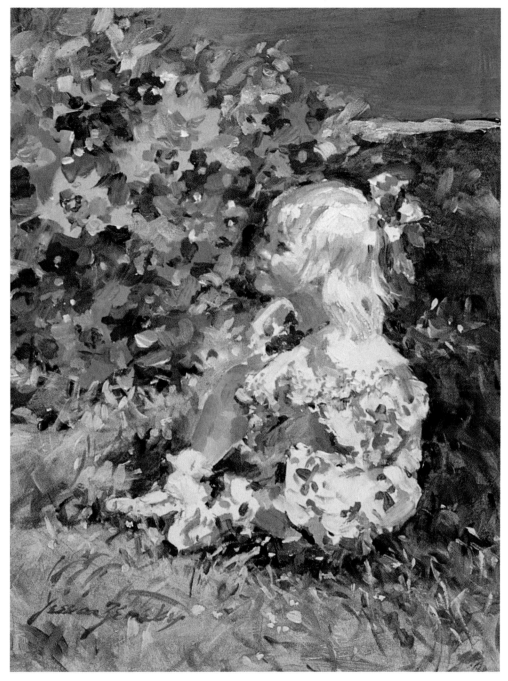

LAUREN'S GARDEN, oil, 20″ × 16″.

7 Casual Composition

Take a last look at the shadow colors, as well as the whole piece. You want it bright, fresh and sunlit. Keep the composition casual. She's all dressed up, but isn't posing; just doing her sunny day thing, being a little girl. She looks like the flowers she's sitting with, but none of them are posing either! Make value adjustments so that you don't lose the subject in the flowers and shadows. Then sign it.

WHEN THE THEN AND THE NOW HOLD
HANDS, oil, 24″ × 28″. Collection of Mr. and
Mrs. Robert Lewin. Copyright Mill Pond Press,
Inc., Venice, Florida 34292.

*This has been the most popular painting
of my career. It seems to say something to
lots of people. It surely had a lot of mean-
ing for me, and if you are touched by a
painting—the idea and the execution—
it will usually affect other people too. For
me the idea was of all the children who
had gone to that school—children who
are gone now—while the school remains,
triggering memories even today.*

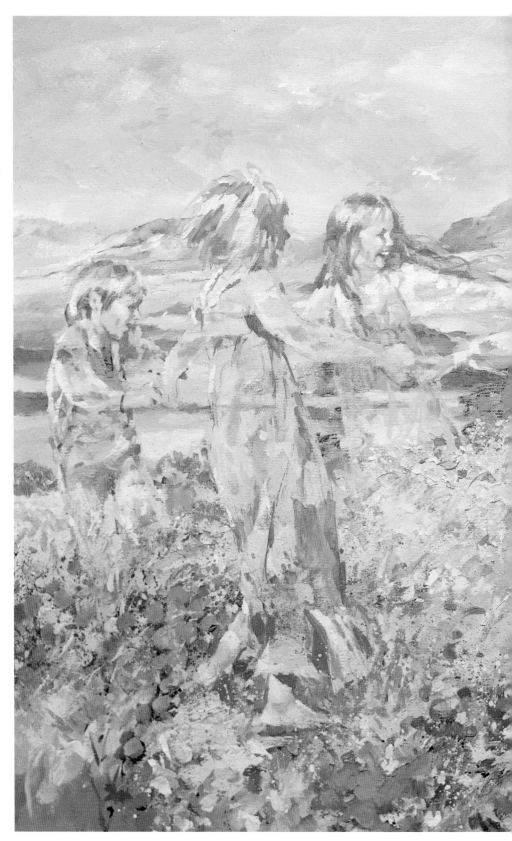

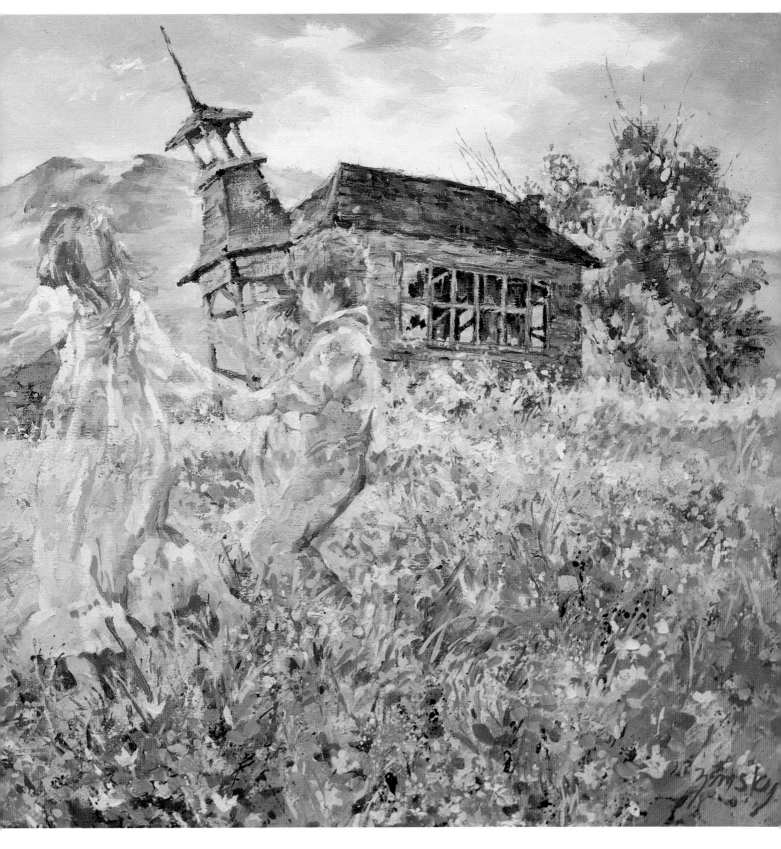

Pastel

Pastels are just marvelous—simple, direct and extremely manageable. There are many different kinds of pastels: hard, waxy, oily, soft. Waxy and hard pastels don't smear easily, and so are good for sketching and drawing. But I like the big, fat, soft ones—it's fun to smear and spread them around. Yum. Many brands can be used interchangeably. Try them for yourself and see. Make your own decisions about the best ones for you.

Each medium holds a special treat for the artist. With pastel, it's bright, fresh and beautiful color. Pastel is pure color—you always see exactly what you're getting. Get lots of different colors of pastel sticks, at least two or three dozen, so you can accomplish anything you'd like.

You can also work on an endless array of surfaces, so try lots of them.

Working on a toned paper gives you your middle value—all you have to worry about is getting your lights and darks right.

Pastels can be worked with your fingers, with blending stumps (also called tortillons), or with just the sticks themselves. Try laying down strokes beside or on top of each other, as well as smudging them together—whatever suits you.

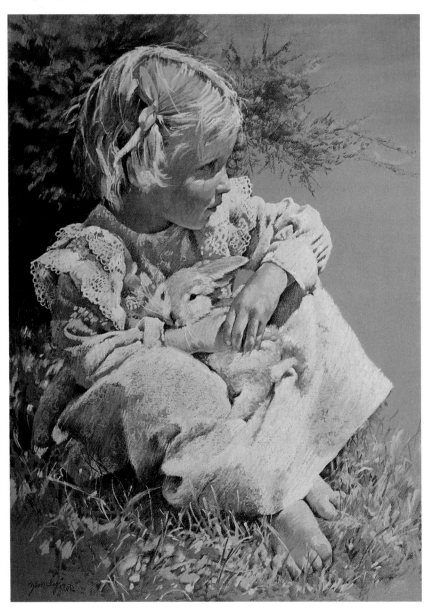

JORDAN'S SPRING, pastel, 20" × 16". Collection of Chuck and Carolyn Gainan.

Hint

To prevent smearing dark pastel dust, work from light to dark, and from the top down. Keeping a piece of paper towel under the heel of your palm helps, too. Paper towels can also be used to wipe off dusty pastel sticks, so that you can recognize their true colors.

The background was laid in first in this piece, then smoothed out with my fingers. Then I laid in the darks of the brush, to serve as a foil for the subject's lovely blonde hair. The high color of her skin is accented against the white of her collar. The pastel is applied lightly, with varying textures and lines—some smooth, some not so smooth.

PASTEL

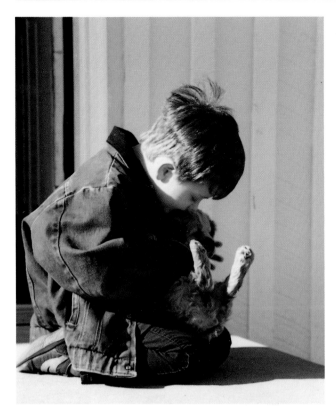

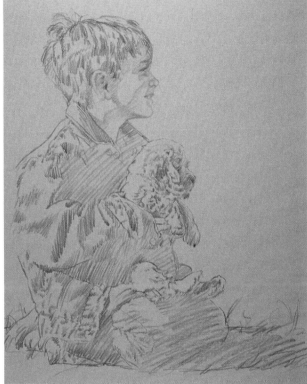

The marvelous togetherness of boys and dogs is a universal theme. This young man is named Leonard, and his puppy is called Cuddle Up To. Aren't they a handsome couple? Notice the nice gestures. They are busy with each other; neither one is interested in this artist, and that's perfect. They typify youth, natural love and life's beginnings. This exact pose doesn't quite work as a composition—it's too rolled up, and there are no visible faces—but I really like the silhouette.

1 *Clean Line Drawing*
Begin by solving the composition, anatomy and overall value pattern of the piece with a good underdrawing. The light comes at the subjects from the left, picking up some detail and framing their backs. Keep the shadow side simple.

Hint

Every step in your artwork is important. You want to be the best artist you can be—and that means all the time! Get used to thinking that way.

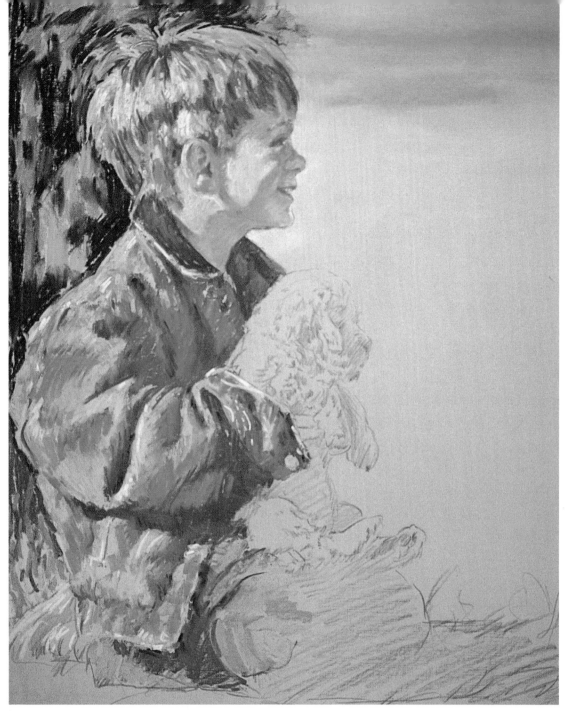

2 *Values, Colors, Shapes*

Drag in warm, pinkish colors for the sky. As you continue to work on the piece, use direct strokes of pastel, with no blending. Continue creating form with directional light and shadow; as with any medium, think values, dark and light. Start with close values, then spread them apart, going lighter and darker. Adding color brings the piece to life; think warm and cool. In a piece like this, the boy's head and the puppy are vital; if they fail, a swell rendering of a jacket won't mean much. Work on the boy first. Paint in the head, paying special attention to the light. Nice, warm shadow colors on the face echo the same pink as the sky. Then work on the blue values of the jacket, starting with light blue, going into darker blues, and interspersing with violets. Take advantage of the sidelight to enhance modeling and suggest hemstitching. And, of course, think shapes, including negative spaces. Lay in the dark bushes behind the figure, feeding some of the greens into the blue jacket. Add oranges into the hair.

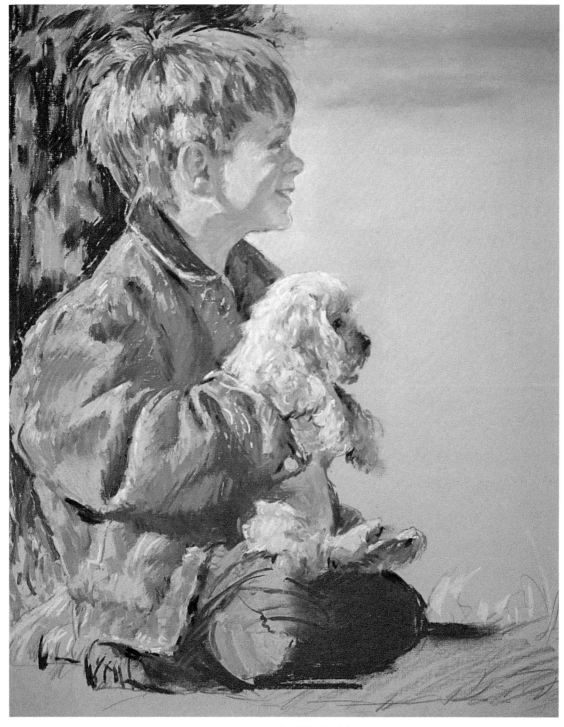

3 *Cuddle Up To*

Paint the puppy in several values of warm yellows and browns, using soft edges for the feeling of fur. Leave the deep shadow for last, so that you don't drag through the dark blue area.

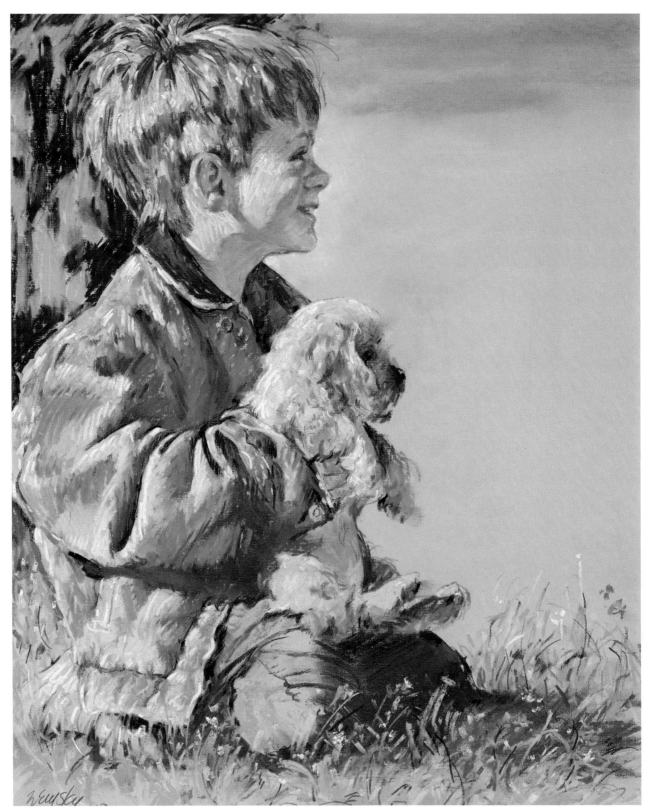

4 Finishing Touches
Add more greens and general finishing touches.

MAN'S BEST FRIEND, pastel, 20" × 16".
Collection of Mr. and Mrs. Leonard Schlabach.

TOO CUTE FOR WORDS, gouache and pastel, 20" × 16".

This painting was done using a composition similar to Man's Best Friend. *Answers for one painting can often work for another.*

MIXED MEDIA

This marvelous little girl, Amarette the adorable, lives with her adopted family on the Blackfeet Reservation in Browning, Montana. Boy, what a kid. I think she'll be stuck with that agreeable personality for life. The colors of her beautiful costume, with the blanket and eagle-wing fan as props, are totally Native American. You can't go wrong if you really strive for that brilliant color using gouache with pastel accents. The setup is outdoors, so make the picture extremely sunny, with a bright look.

1 *Drawing*
Lay in the drawing. The angle of the fan creates a nice tension with the subject's hair and the gesture of her head.

> **Hint**
>
> If you're familiar and comfortable with many different mediums, there are more possibilities for achieving the effect you want. Choose whichever suits you best for each piece.

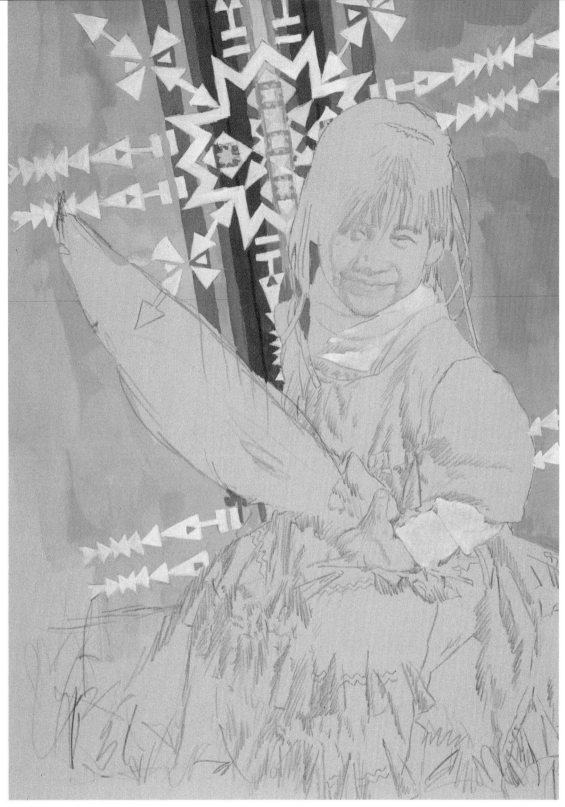

2 Sizzling Color Background

Start with the "habitat," as wildlife artists say, then fit the subject into her environment. Paint in the warm sun colors of the blanket first, to set the bright color that will really enhance skin tones. Run a strong, flat wash of Golden Yellow and Cadmium Orange gouache right over the white pattern, which you'll reestablish later on. With a flat brush and a dry-brush method, use Gamboge or Indian Yellow with Carthamus Pink to really make the color scream. Don't mix and blend colors much—use them as pure and right from the tube as you dare. For the stripes, use Flame Red, Carthamus Pink and Geranium. Reestablish the eye-catching white shapes of the blanket design.

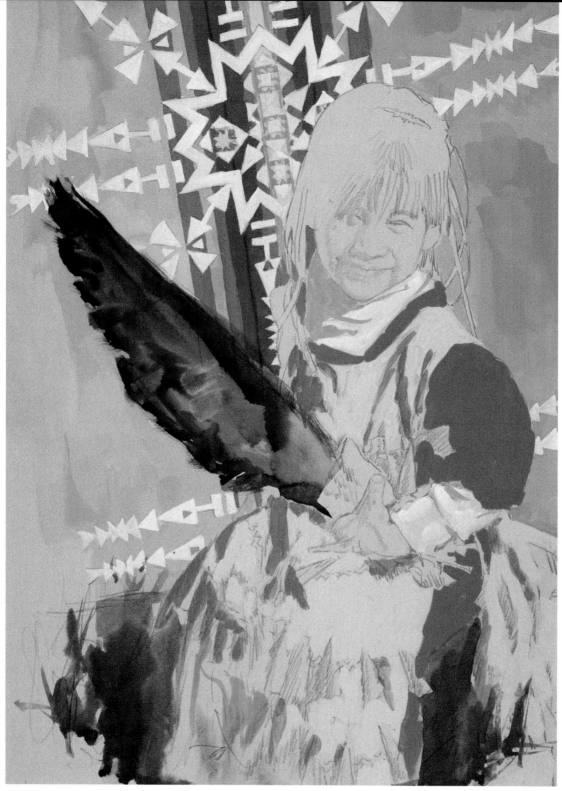

3 Clothing, Fan, Grass

Add some hot pinks, altering the clothing for the painting. Without mixing too much, use a largish brush (about no. 16) with local colors right from the tube to block in the subject's dress (Bengal Rose), buckskin jumper (Naples Yellow), and shirt (Bengal Rose with a touch of white). Rough in the dark fan with a mixture of Cadmium Red and Prussian Blue wash. Since the subject is placed in such a strong orange atmosphere, reflect that hot color in the shadows of the buckskin. Also add cool shadows. Block in the dark grass.

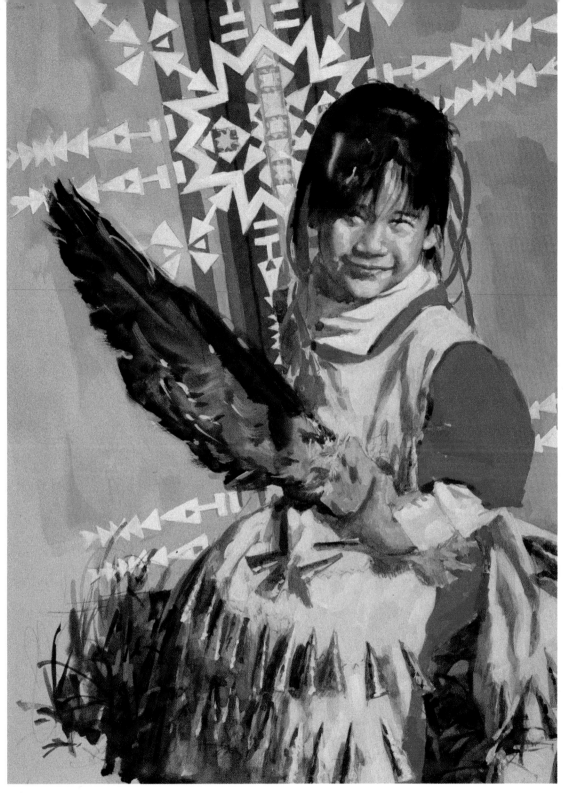

4 Skin, Hair, Dress

Now work everywhere around the painting. Before establishing skin tones, get clean water and a clean palette. You want your color to be as clean and fresh as possible, so you don't drag old paint onto the fleshtones. Start with Naples Yellow, orange and Carthamus Pink, keeping ethnic color in mind. Wash in the subject's hair, as well as a pattern of darks, with the same terrific mixture of Cadmium Red and Prussian Blue used for the fan. Indicate the cones that gleam on her dress. Brighten the color of the dress with Cadmium Yellow Pale and white, using a dry-brush technique. Handle everything as simply as you can up to this point.

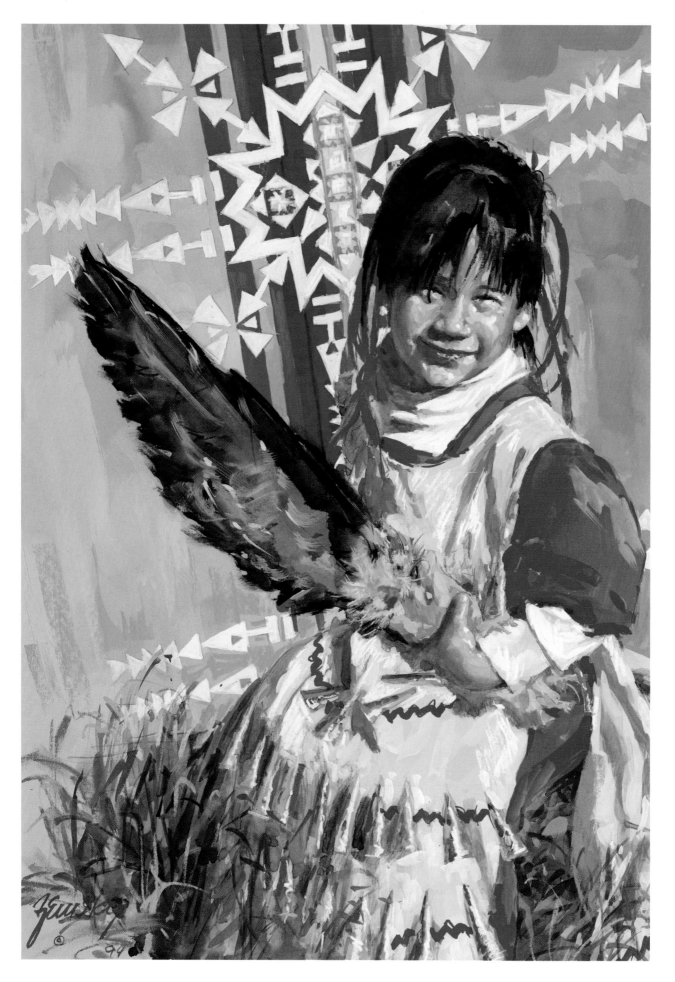

5 *Final Details*

Bring everything up to an almost-finished state. It's time to reassess. Think composition: thrusts, center of interest, eye movement, value, naturalness of pose. Handle the final details loosely, achieving a contrast with the clean-edged pattern of the blanket. Go over the whole piece: lightening, softening, adjusting. Work on hair and ribbons. Concentrate on portraying the things that attracted you to your subject in the first place. Do you like it? Does it read well? A few well-placed strokes of clean, bright pastel and she's finished. The shallow space of the composition, with warm colors advancing, really locks the viewer in close to the subject, making for an intimate feeling.

Left:
EAGLE WING FAN, gouache and pastel, 24" × 20". Private collection.

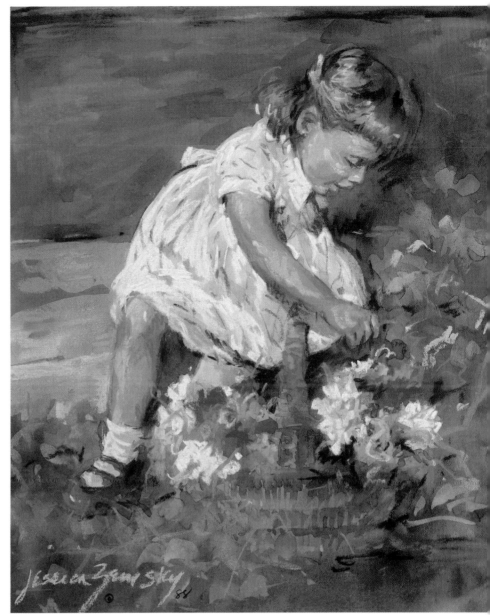

MONTANA SUMMER, gouache, 20" × 16".

Hint

It's awfully hard to keep from going for the cute little details right away, but hold your horses until you get your whole painting developed to the same degree of finish. Then let yourself enjoy all the details.

The Icing on the Cake

If you've been working with gouache or watercolor, a few strokes of pastel can be the icing on the cake, bringing up lights, or making a child's soft hair tendrils. If you've paid attention to what you've done, and done it right, pastel can add the personal note that's you. Using pastel for finishing touches and details adds zest to your painting.

Pastel can also magically fix areas that you're not satisfied with. If you're left with a blotchy spot, for example, you can use pastel to smooth it over. A too-hard edge can be softened, a muddy color can be cleared up. Have some pastels on hand—they're a great addition to your bag of painting tricks.

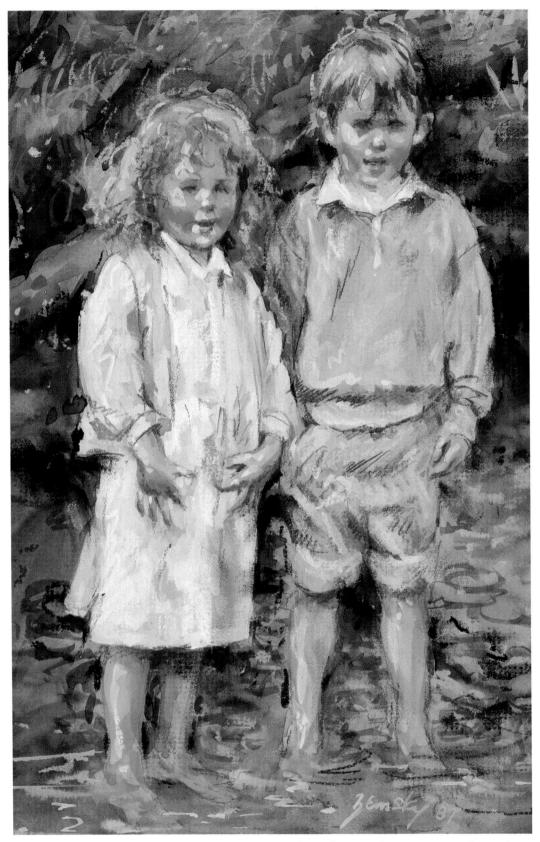

COUNTRY KIDS, gouache and pastel, 12″×9″. Private collection.

These two little people are wading in a stream, doing what kids do. The painting is very fresh, with lots of fun. Quick pastel strokes help to keep a casual feeling.

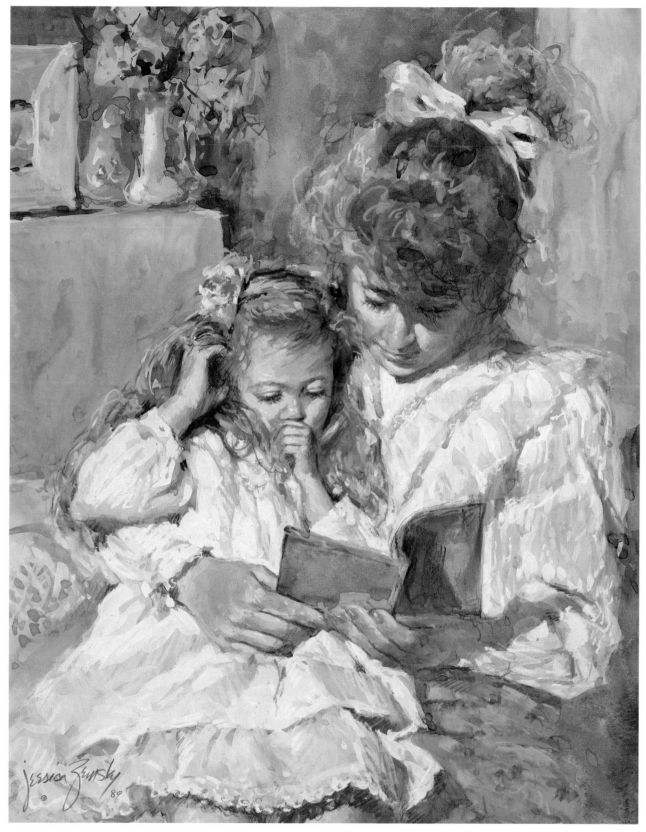

ONCE UPON A TIME, gouache and pastel,
24" × 20". Collection of the artist.

*The icing in the mother's hair is full of color, freedom and
softness. Try finishing your paintings with pastel—you'll have
fun, and get great results.*

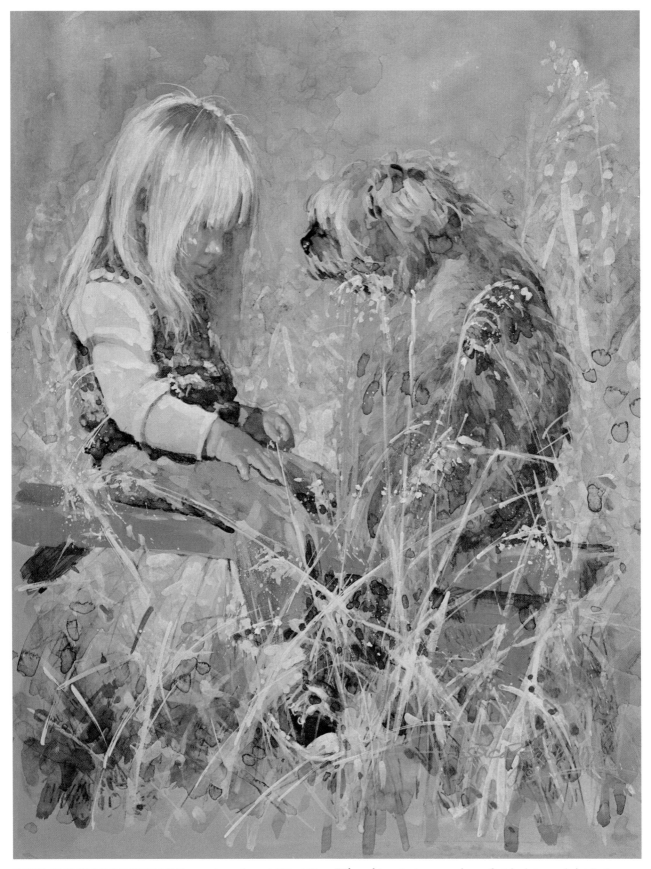

THEY'LL BE SORRY WHEN WE'RE GONE, gouache and pastel, 20″ × 16″.
Private collection. Copyright Mill Pond Press, Inc., Venice, Florida 34292.

When this painting was almost finished, it needed a little something. That something was pastel. It added crispness to the slender grasses, and just enhanced the piece overall.

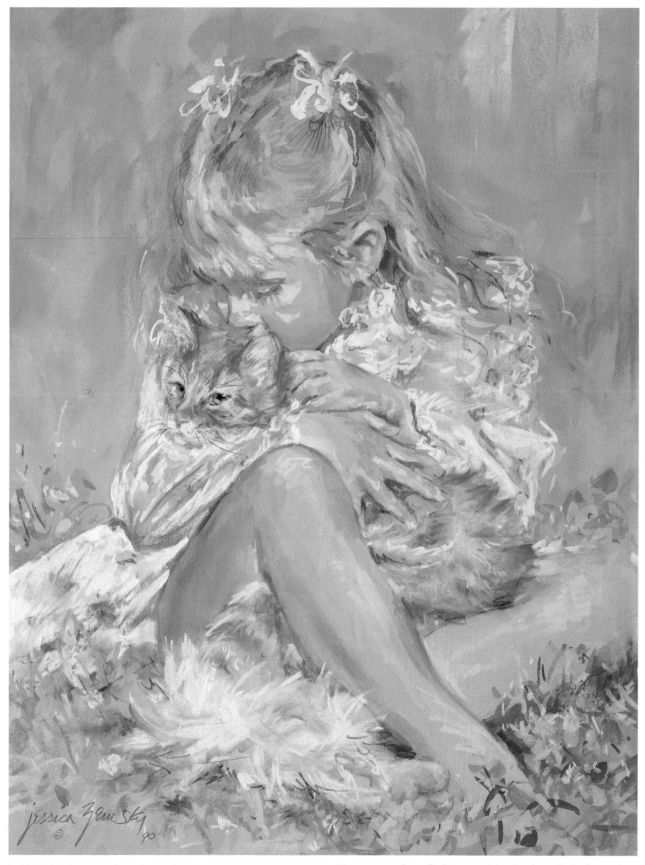

BUTTERSCOTCH, gouache and pastel,
24"×20". Private collection.

Here you see lots of white pastel in the dress, hair decoration, and the kitty's tail fur. It shows how pastel works as the icing on the cake.

jessica Zemsky NWR
© 83

Drawing

Drawing as the underpinning for a painting is a very different kettle of fish than doing a finished drawing as an art piece. In the first case, you don't want to get involved in too much detail or tonal renderings. Keep it simple, but make your drawing the best it can be. Facial expressions are important, as are the gestures of fingers and hands. But don't draw out all the leaves on the trees, patterns on clothing, or flowers in the field; just suggest them. This drawing is a sort of map to help you find your way through the painting. A painting will naturally change as you progress, but the drawing underneath will still flavor the finished piece.

Drawing is a basic foundation of art, and it's a lot of fun. For many people, drawing is the whole of their art experience. It can stand on its own; it's like playing the piano as opposed to having a full orchestra. If you're drawing to achieve a finished piece, you can embellish and vary the line any way you choose. Use tone, work with different strokes or crosshatching, use thick and thin lines. Do whatever it takes to make a beautiful rendering. Drawings can be as lovely as paintings.

Develop a Sketchbook Habit

It is important to draw as much as you can. Drawing is the exercise habit of the artist, and like the exercise of the athlete, it must be pursued often. You can easily achieve this by carrying a small, inexpensive sketchbook around with you at all times. If you get in the habit of sketching many things, not only children, you will noticeably improve your drawing and observation skills, and you'll also develop an invaluable reference resource.

Left:
TIRED, colored pencil, 20″ × 16″.
Private collection.

DRAW FROM LIFE, OR FROM PHOTOS?

It all depends on the model, no matter your subject's age. When drawing children from life, they really need to be old enough to know what you're trying to do and be willing to help you do it. Their "sit-still span" is about half an hour, at the most, with periods of running around, getting a drink of water, and going to the bathroom. So have your surface, lighting and drawing tools ready. The only thing you can afford to take time with is a good look at your model. Consider the child's personality and age. Then decide how much to get down on paper to capture the mood you want in your drawing.

Sketching directly from a model is extremely useful. Anatomy is, of course, very important when drawing people. The human figure is divine, but not easy—it must be rendered correctly. A group of trees or a vase of flowers can be altered to help a composition, but your proportions have to be right with figures. Your understanding of anatomy can make or break a piece, especially with children; they are always changing—their proportions help indicate their age. So get a sketchbook, and start making quick drawings of as many figures as you can. The more you observe, the better you'll become. A good anatomy book will also help. Go through it often, until you're familiar enough with the human body to be on your own!

A few color notes in your sketchbook, made directly from a model on location, will help keep your paintings fresh and lifelike when you're trying to re-create a situation for a finished piece—photos can sometimes look unnatural.

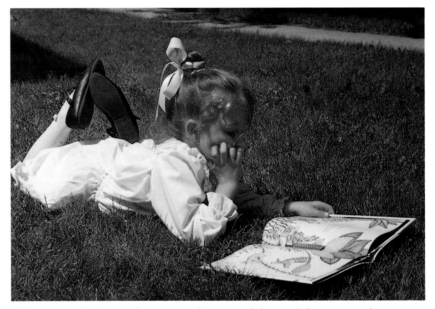

This picture of Julia reading is one of many. I did several drawings and a painting from this one successful photo session.

Hint

A warm brown colored pencil gives your drawing a beautiful, somewhat softer look than graphite.

Right:

JULIA READING, Prismacolor pencil, 24" × 20".

The drawing at right was done with photographs, including the one above, as references. It is a careful and affectionate depiction of Julia lying out on the grass in summer, with all her attention on a big, beautiful picture book. A lovely feeling of sunlight, breeze and relaxation comes through. Her gestures—the tilt of her head, the bend of her fingers—are her own, giving a very sweet authenticity to the piece. Directing a child's pose too much is guaranteed to kill a natural look.

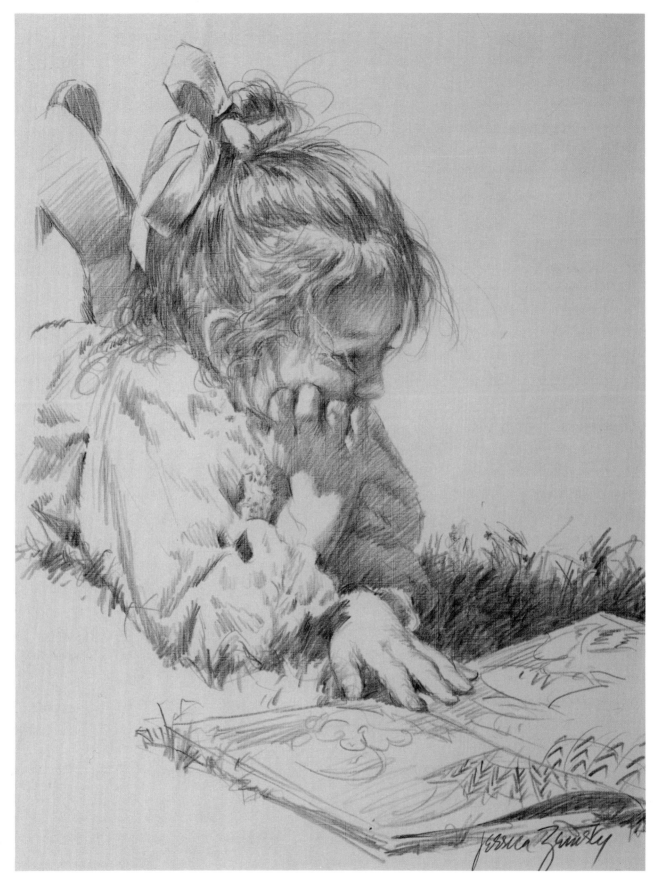

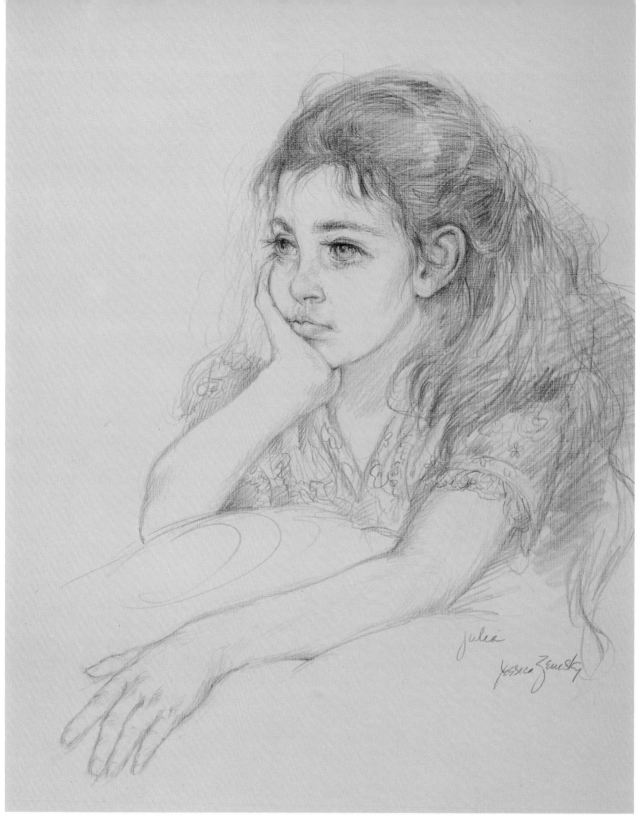

Julia

Jessica Zemsky

DRAWING JULIA
FROM LIFE

Julia found a nice, soft pose. A scene outside with kids moving about held her gaze, showing her dreamy type of beauty to great advantage as I sketched her. Notice how the drawing is composed with a lot of room for her to gaze into. After Julia left, I went back in to accent some passages.

I hope this drawing of Julia will make a believer out of you. Drawing from life is wonderfully satisfying. It will wean you from the exclusive use of photographic references, bringing you closer to your models.

This is the same girl as on the previous page, but a different look. Drawing Julia from life was a pleasure. She's old enough and sweet enough to understand an artist's need for cooperation. Her beautiful dreaminess is all in her eyes and can't be captured adequately by a photograph.

THE HUG, colored pencil, 20" × 16".
Collection of Mr. and Mrs. Peter Aronow.

Hint

Looking at drawing styles from every era of art history is good for you, but don't strive too hard to cultivate a particular style.

Developing your own personal way of working as you try different materials and master the mechanics of drawing is very rewarding.

Hint

Try to use different strokes for the different parts of the body. Hair needs a different treatment than a turning cheek.

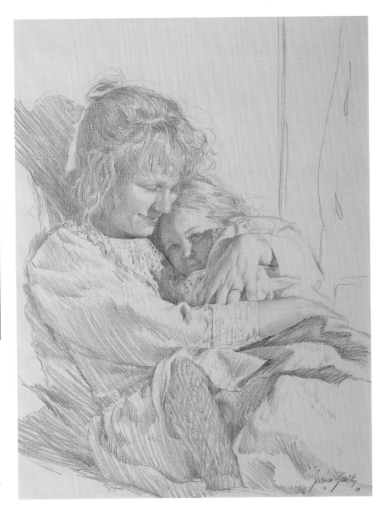

IN MOMMY'S BED, colored pencil, 20" × 16".
Collection of the artist.

Sweetness and Light

Sometimes you'll hear someone say, "That looks so real!" In order to accomplish a semblance of realism, you need to know how to suggest form using the effects of light and shadow. You can't fake the light on a subject's face, so use a good reference. Features are easily distorted if lights and darks are poorly placed. Establish your value structure early on, and make it work for you. Sidelighting can enhance form; backlighting is gorgeous for flying hair and to achieve the feeling of a sunset.

ALMOST GROWN, gouache, 24" × 20".
Collection of Mr. and Mrs. Bruce Lee.

ROBIN IN THE WINDOW, gouache, 24″ × 10″. Private collection.

This is a good example of a value study. Sunlight streaming in from the left highlights the whites of the figure, while the shadow side, in purples and blues, goes quite dark. There are gradations from light to dark, and some soft, lost edges which melt the figure into the shadows.

Value Contrast

Use light to create a feeling of balance in your painting, working lights and darks throughout a piece and keeping contrast in mind. What works for you? Are you painting a dramatic piece with intense contrasts, or all sunlight and brightness? Adjust your values to do the job.

Hint

If you can visually explain highlights and shadows successfully, you can leave out a lot of the middle values, and the viewer will still understand what the figure is up to. It's sometimes very interesting, involving and challenging for your audience to have a little work to do themselves, rather than having every inch of a piece spelled out for them.

ONE SHEET TO THE WIND, gouache, 24″×20″.
Collection of Mr. and Mrs. Harry Gerham.

This girl in white, standing in front of dark trees, is a good example of contrast. Notice the hints of light in the background, and the dark colors of the trees and sky reflected in the white sheet. The dark shadow area on the girl's face also relates to the background.

Light Temperature

Light temperature is important too. A cool light will suggest a calm, peaceful atmosphere—perhaps evening. Warm light suggests sunshine, heat, summer, joy, excitement. The effects of light are always important and need to be dealt with. Be aware of light, and use it to your advantage.

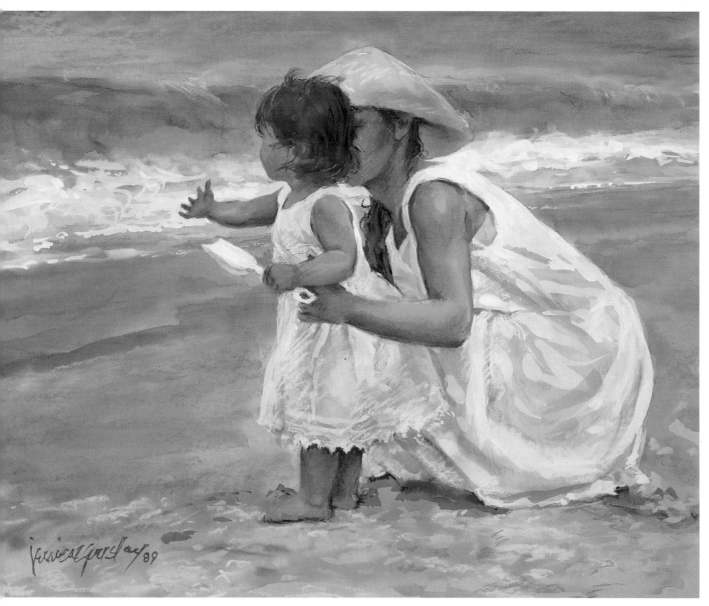

BY THE SEA, gouache, 16" × 20". Collection of Jamie Aronow.

These two paintings are good examples of light temperature. The one at right has a warm, golden, indoor lighting situation that floods the room and the subjects with an intimate look. The seaside scene above is set in a more natural, overcast light, with a muted coolness reminiscent of salty sea spray.

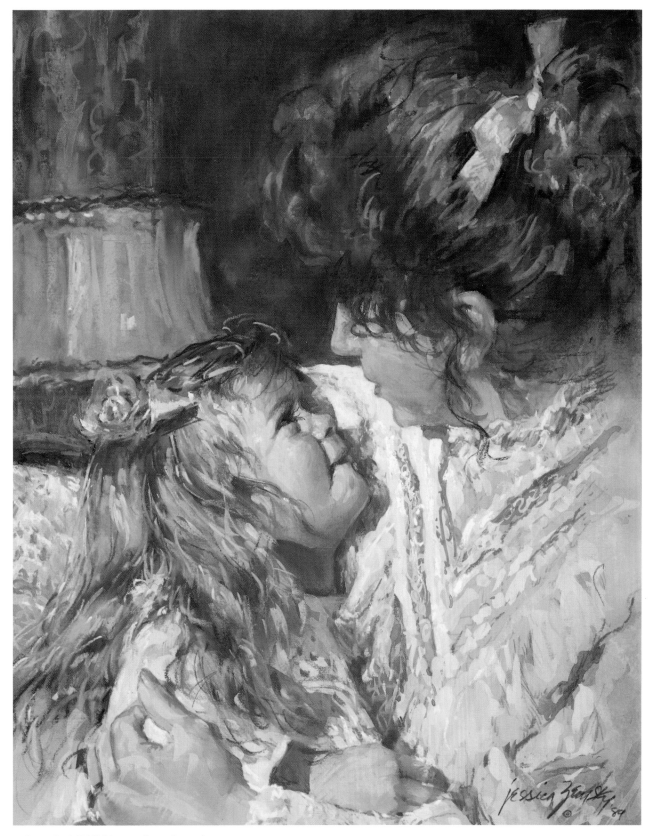

I LOVE YOU MOMMY, gouache and pastel,
24" × 20". Collection of the artist.

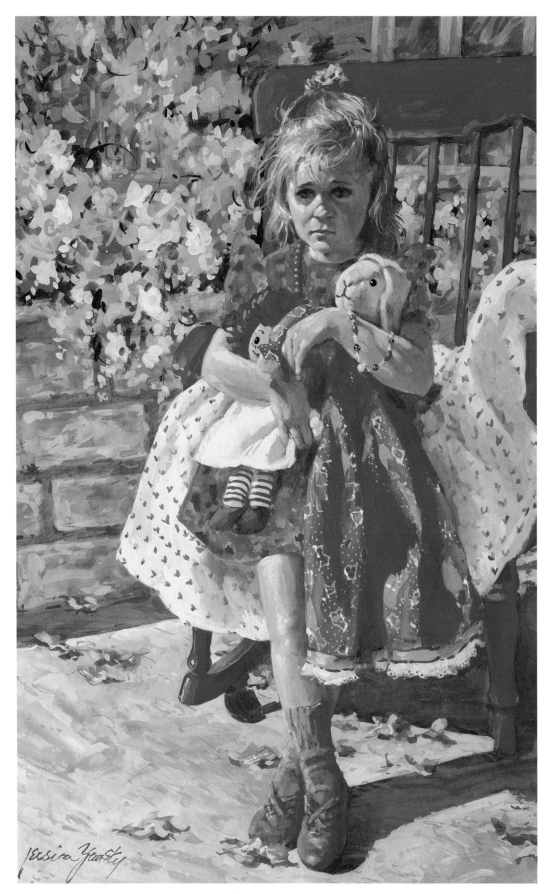

BLUE IN PINK JELLIES
gouache and pastel,
30″×26″. Collection
of the artist.

*The light in this
piece is very warm,
even in the shad-
ows. Even the cool-
est bits of blue are
the warmest blue
on my palette—
Periwinkle Blue.
The shadowed eyes
have no highlights,
though there are
highlights in the
dolls' eyes.*

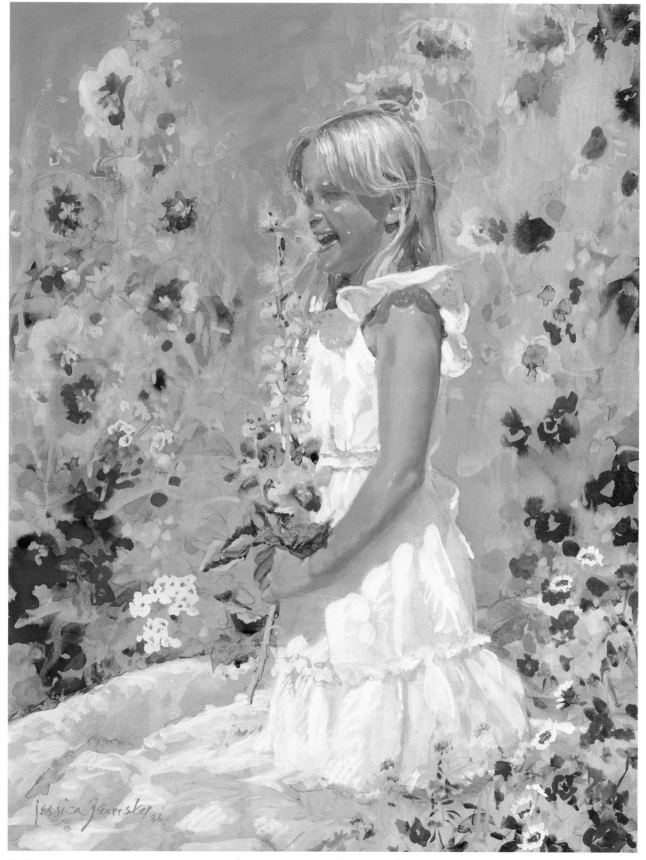

TAKE TIME TO SMELL THE FLOWERS, gouache and pastel, 24″ × 20″. Collection of the artist.

This painting is a good example of warm light used to depict sunshine, summer and joy. The whole thing expresses what light is all about: a clear Montana sky; flowers growing free in the sun; how white reacts to other colors in full light.

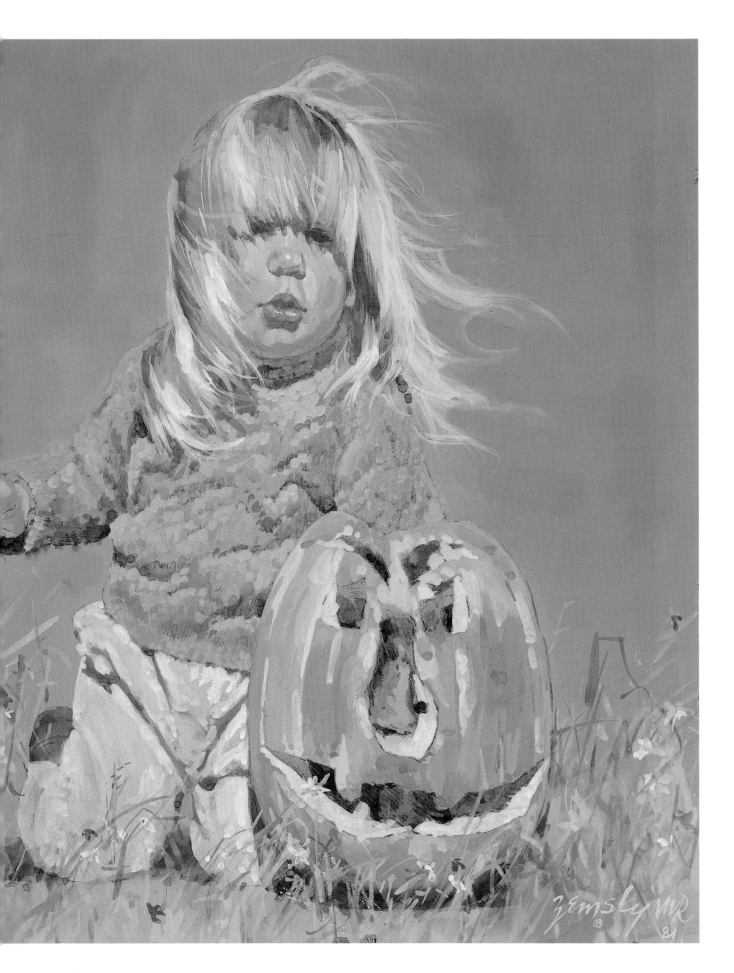

Color, the Magic Ingredient

Color pulls your whole painting together, expressing time of day, mood, personal feelings and unity. The way colors relate to each other gives your painting a certain feel. Keep in mind that you can do much more than just re-create the local color of a subject. There are special color considerations for achieving the lovely, living look of children in your paintings. Look at the children around you. When you're setting up for a painting, try to choose props not only for subject matter, but for color too! Colors are fun, so work with them.

HALLOWEEN FACES,
gouache, 20" × 16".

White Areas

White reflects color and light in such gorgeous ways. It has a wonderful way of picking up the colors around it while still keeping its integrity as white.

Hint

Get a lot of white, whatever your medium. It is helpful for bringing up the value of color. You don't want your color to be chalky, but if white is used discreetly, it can achieve lovely, opalescent tints.

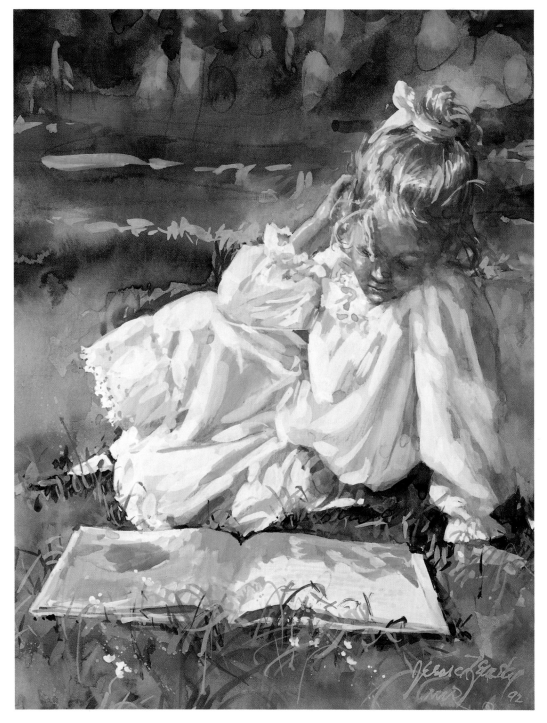

STORY TIME, gouache, 20" × 16". Collection of the artist.

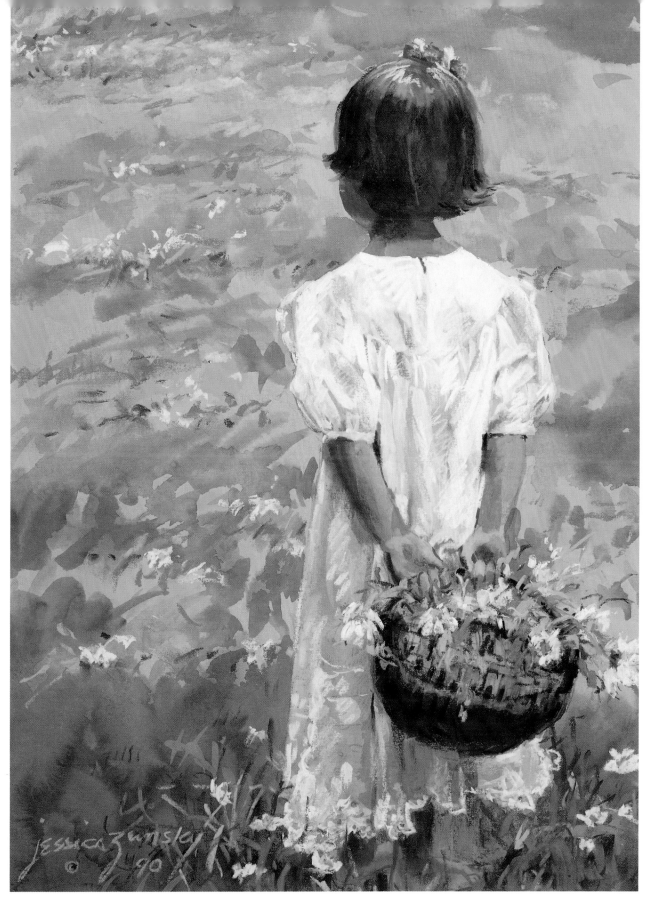

END OF SUMMER, gouache, 20"×16".

Color Harmony

No matter how many colors you may be juggling at one time, try to create harmony and unity. For example, if you are using green in one area, look over the whole painting surface; find a few places to use that same color again, even if it means working a greenish stroke or two into a violet area. Color that moves through a piece can also be used to guide the eye of the viewer. Notice on this page how the tones in the shadow areas are full of color, enhancing the foreground and carrying pigment all through the painting. Thus the painting achieves balance and harmony.

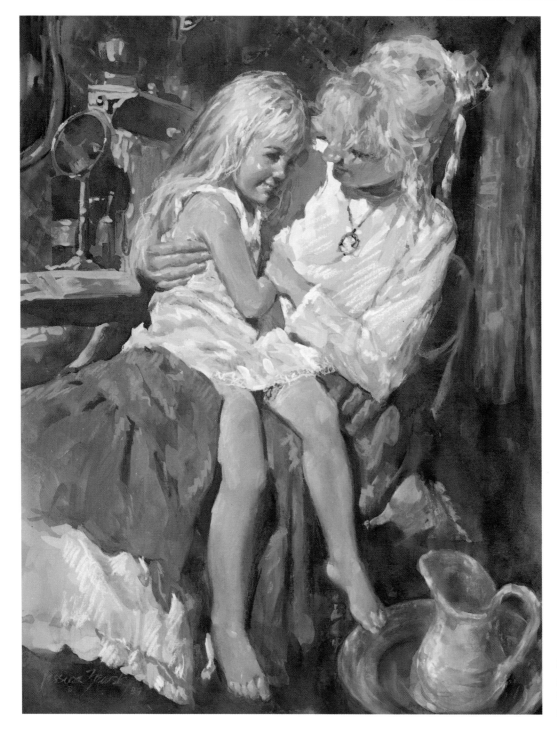

BEFORE THE BATH, gouache, 24" × 20". Collection of the artist.

Darks

You can make darks—even ones like the hair of the girl on page 60, or that of the little girl on this page—and never touch black. Mix rich darks to fit into your color situation and avoid creating black holes.

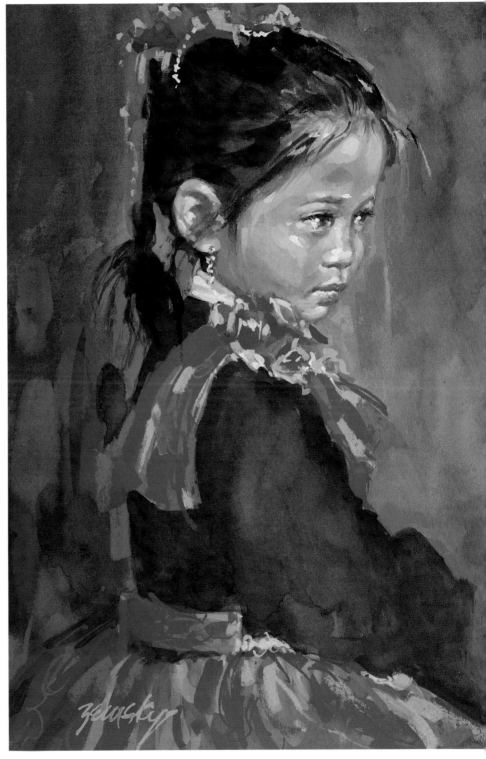

VIKKI, gouache and pastel, 24″ × 20″.

Hint

Never use black, especially on faces. You can make lots of terrific darks without it, and if it's on your palette, it'll get dragged into something and kill your color. Trust me. Keep in mind that children's skin must suggest the juices of life, so use warm, red-related pigments to describe nostrils, where lips come together, and around eyes.

Warm Tones

The painting on this page is done in warm tones of pink and lavender. Such an outdoor scene might be more factual if done in cool blues and greens, but an artist is free to be original. Try to paint a feeling, not just a place.

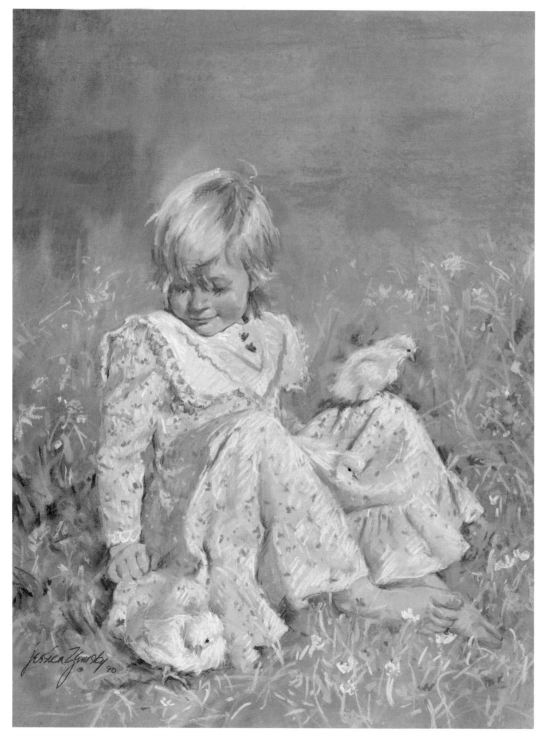

SPRING CHICKENS, gouache, 24″×20″. Collection of the artist.

SLEEPING IN, gouache, 20" × 24". Private collection.

Cool Tones

The painting on this page is about color and light. That blue is wild, but it works. Color is your choice—it's up to you.

Hint

Earth colors are pigments such as Yellow Ochre, Burnt Sienna, Burnt Umber and Raw Umber, which are made from minerals. Don't lay in too many of them on your palette, because they turn to dirt (which is pretty much what they're made of) pretty quickly, and a neutral color is easy to achieve by mixing other colors.

COLOR HARMONY WITH PASTEL

Pastels are pure color, and can go very bright and strong, but if you want to do a pastel painting in soft, light colors, that's your choice.

Pastels come in different degrees of softness or hardness. Try lots of brands, then choose what answers your needs. I like the big, fat, soft pastels used for this demonstration.

1 Colored Pencil Drawing
With pastel there is no need to stretch or mount your paper. However, it is a good idea to put an extra sheet or two under the toned drawing paper, making a nice pad to work against. Do the drawing in brown colored pencil.

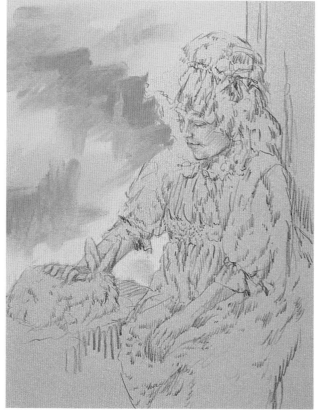

2 Soft Background Colors
Begin to establish color harmony by softly rubbing in background colors—light yellows, peaches, pinks and violets—to be used again elsewhere in the painting. Place these pastel sticks aside, where you can easily find them later.

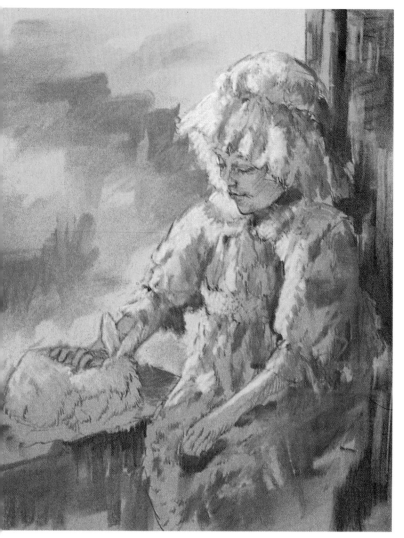

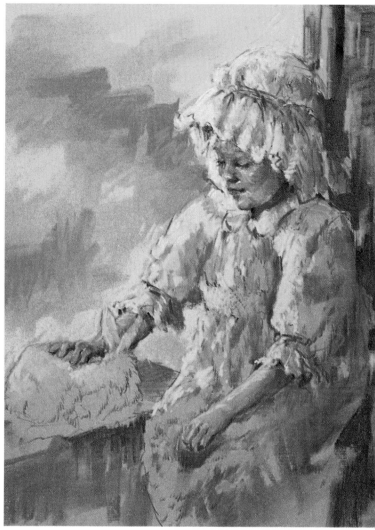

3 *Value Pattern*
Rough in related tones, deciding on a value pattern of light and dark for the piece and its subject. A soft piece like this will need to stay with light to mid-values overall. Place the lights of the subject's bonnet and dress. Lay in the value of the rabbit. Add some darker violets for shadows, and a neutral green for interest.

4 *Fresh, Lively Face*
Work on the subject's face, trying to portray her as alive and fresh.

Hint
If you can get the face and head in well, the rest is a shoo-in.

89

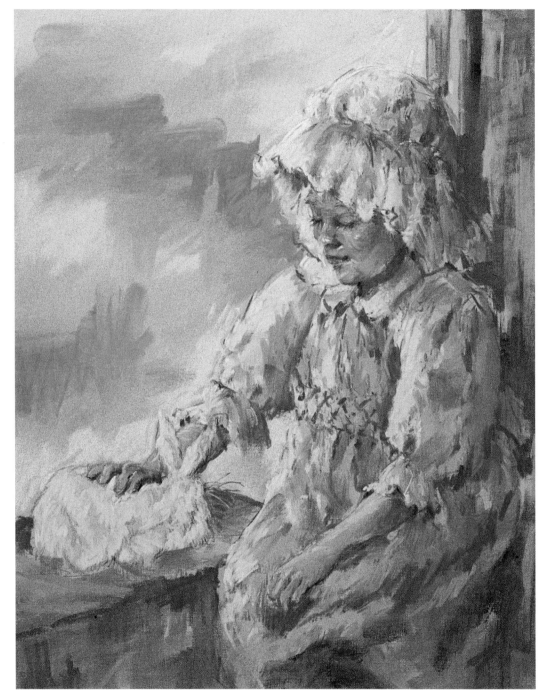

5 *Color Harmony*
Think harmony, completing the surface with warm, re-
lated colors, as well as cool violets and blues in both shadows
and light areas. Make all the parts sympathetic to the whole.

Hint

You can read my suggestions, but it's your
job to try them, and then perhaps find your
own solutions to painting problems. The
solutions you discover on your own are by far
the best, and the ones you'll never forget.

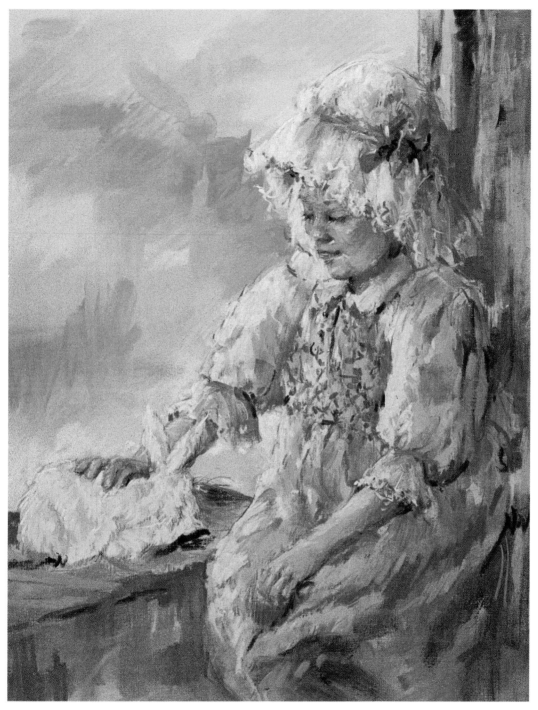

6 Lights and Darks

Rework the background, adding color notes that relate to the body of the painting, tying it all together. Add a sunny yellow outside the window, but keep oranges and pinks mixed in. Flood the piece with sunlight. Add cool, muted greens and violets in the darks. Strengthen the drawing by going back in with colored pencil. Continue to work on the light of the piece, keeping the child and rabbit very close in color and value. Add lots of pattern to help the Victorian mood.

Hint

study your edges. Where do you want a hard edge? Where do you want a soft edge?

PAULA'S MOTHER,
pastel, 20″ × 16″.

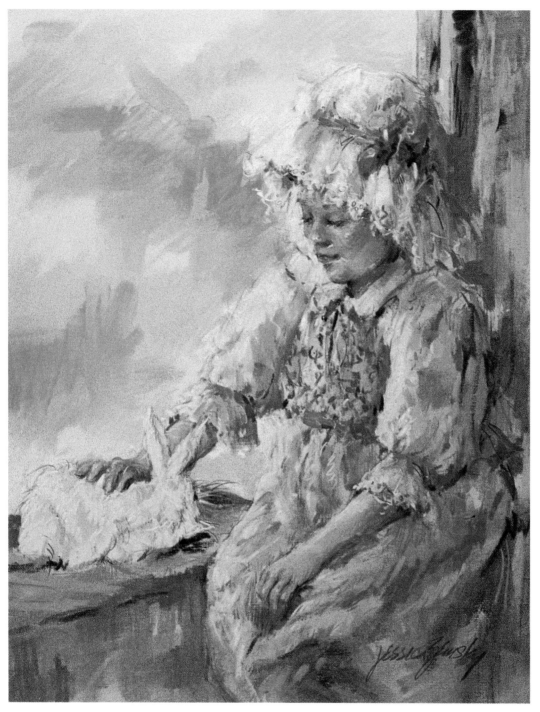

7 Reevaluate and Readjust

Does the color harmony work? Don't be afraid to make changes, using whatever works for you to achieve the most beautiful result you can. The final piece is soft and gentle, with lots of lost and found edges.

Hint

Work on the complexion, or "life" of the sitter, but don't rework too much. Better to start fresh if you want your subject to look fresh!

LITTLE GIRLS, BIG GARDEN, gouache and pastel, 24" × 20".
Private collection.

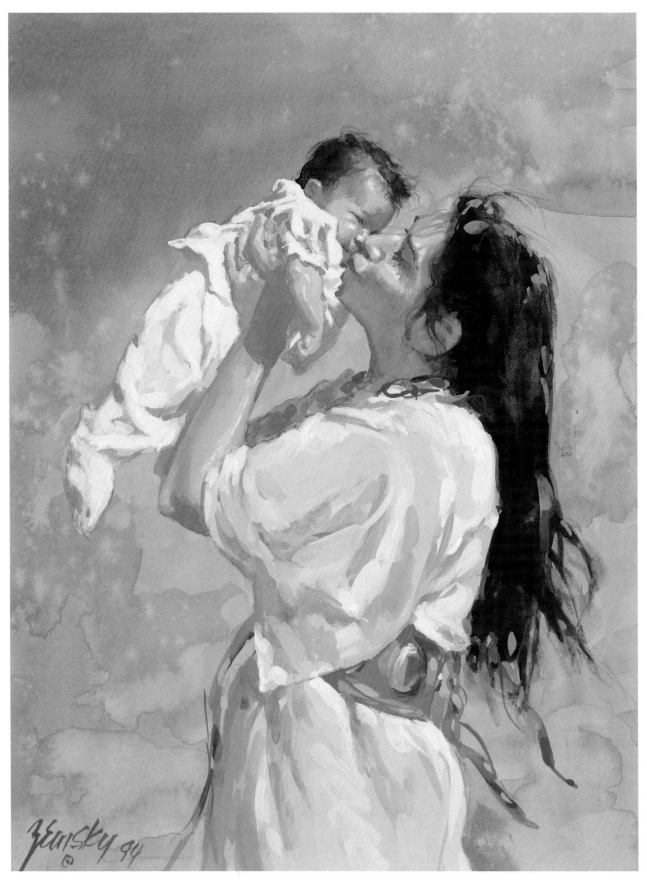

HER DAUGHTER, gouache, 12″×9″. Private collection.

Head, Shoulders, Knees and Toes

All children are different, with complexions and hair colors from fair, to medium, to dark. I can't tell you exactly what to mix in any situation, but I can give you some basic recipes to help with your color mixing. Be sure to experiment with your own subjects.

Skin

There's more to fleshtones than mixing up base color and applying it all over the skin areas. A flat color is not as effective as a varied tone. No matter what kind of skin tone you are trying to render, don't start with white. Naples Yellow will give lighter fleshtones a nice warm base on which to build.

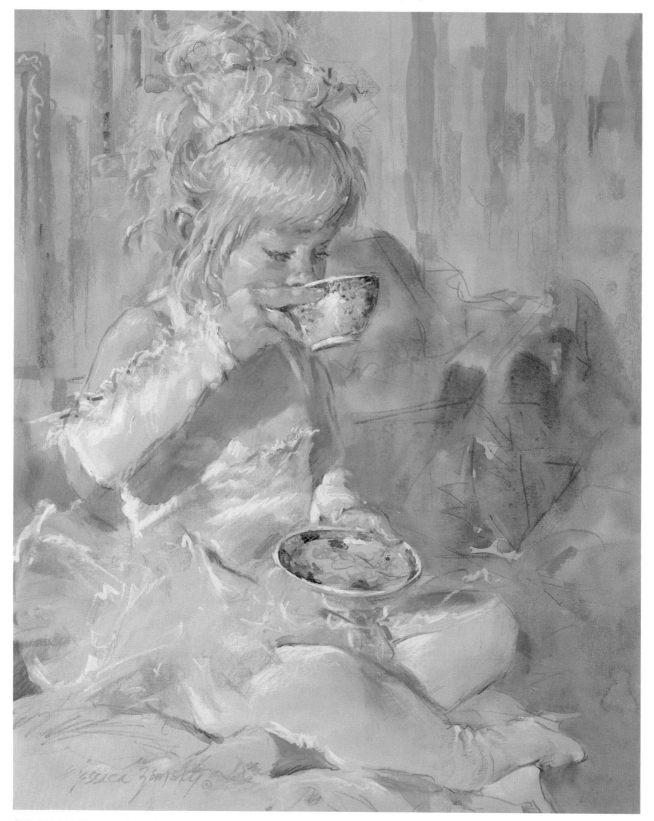

CUP AND SAUCER, gouache and pastel, 24" × 20". Collection of the artist.

SPRING SONG,
gouache, 12″ × 10″.
Private collection.

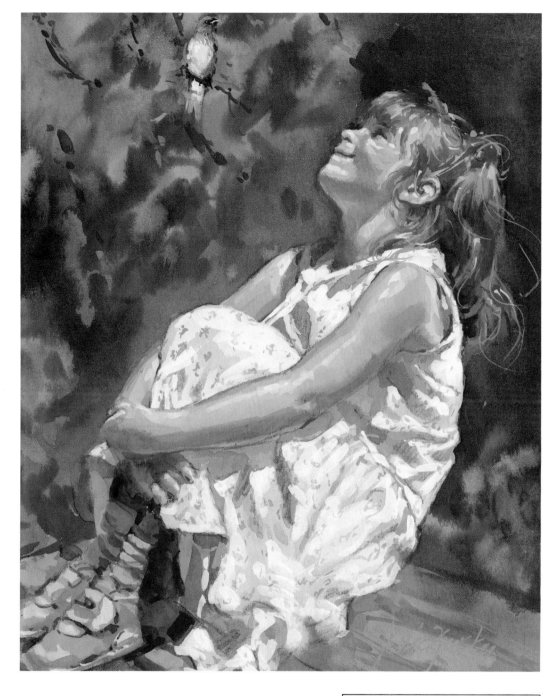

Hair

Blonde, brown, black or red; you can't just mix up paint for hair like a batch of dye and pour it over your subject's head—if you do that's just what it will look like!

Children's hair is often more fine than adult hair, with a softer hairline, and more tendrils and cowlicks. Kids' hair is also usually less formal.

Hint

Your subject's hair may look like it needs combing and a cut, but don't neaten it up, if you can help it. Give your subject a chance to look like a kid.

White Blonde

SKIN COLOR

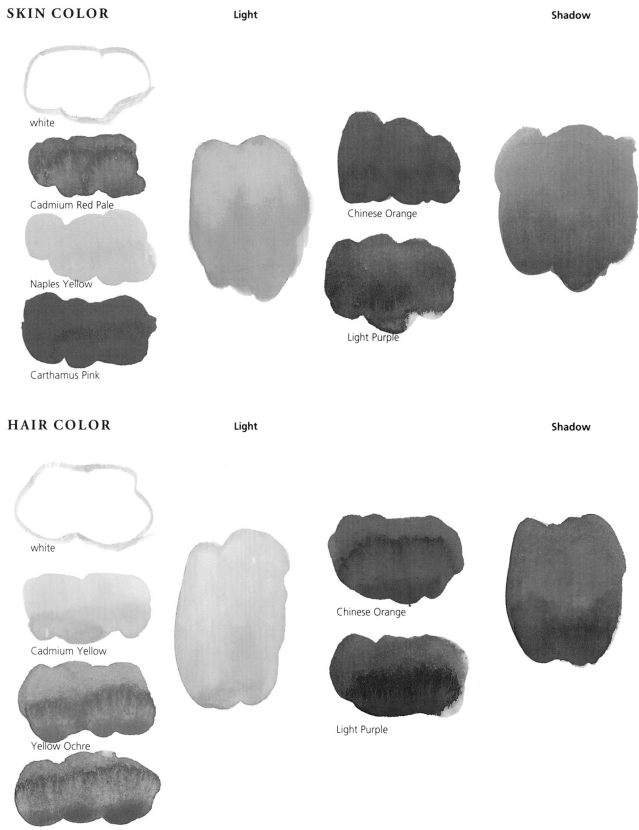

white

Cadmium Red Pale

Naples Yellow

Carthamus Pink

Light

Chinese Orange

Light Purple

Shadow

HAIR COLOR

white

Cadmium Yellow

Yellow Ochre

Oxide of Chromium

Light

Chinese Orange

Light Purple

Shadow

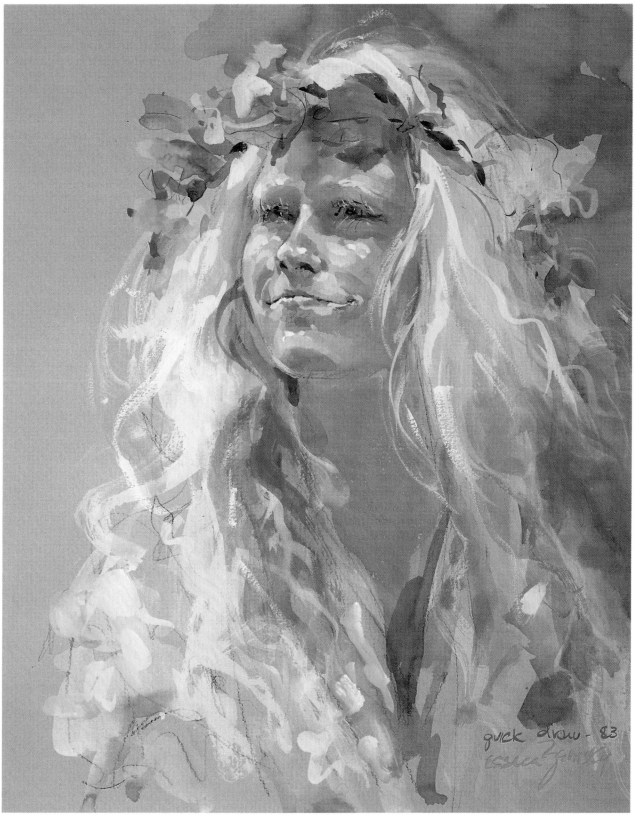

JEANIE, gouache, 20″ × 16″. Private collection.

This saucy young lady is about as loose a rendering as you can have and get any likeness at all. Her coloring is so fair that even her eyelashes are blonde. The strongly lit side of her head is in warm tones, with a cooler shadow side. Everything is simplified; the handling of the hair is extremely free.

Hispanic

SKIN COLOR

Light

Shadow

white

Naples Yellow

Cadmium Orange

Chinese Orange

Light Purple

HAIR COLOR

Light

Shadow

Light Purple

Chinese Orange

Winsor Blue

Light Purple

Winsor Blue

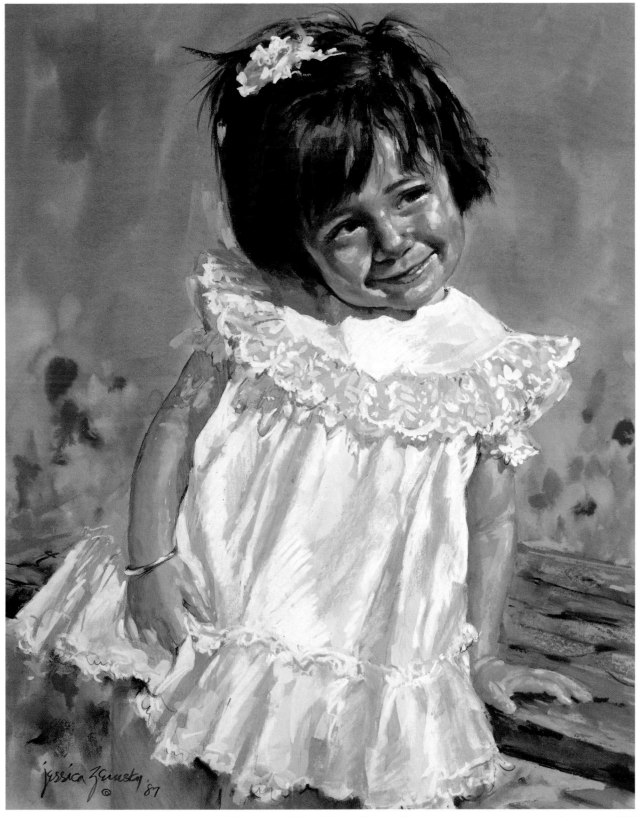

SHY, gouache, 24″×18″. Private collection.

This little girl from Mexico has it all: extreme composure, rare in such a young child, and the most endearing manner imaginable. Her hair is as black as you'll ever see, but it's not black in this painting; it's painted with purples, blues and warm reds. Her sun-kissed skin, accented by her white dress, is a warmer, richer color than that of many very young children.

Blonde

SKIN COLOR

Light

Shadow

white

Naples Yellow

Cadmium Orange

Carthamus Pink

Chinese Orange

Light Purple

HAIR COLOR

Light

Shadow

white

Naples Yellow

Cadmium Yellow Pale

Yellow Ochre

Light Purple

Oxide of Chromium

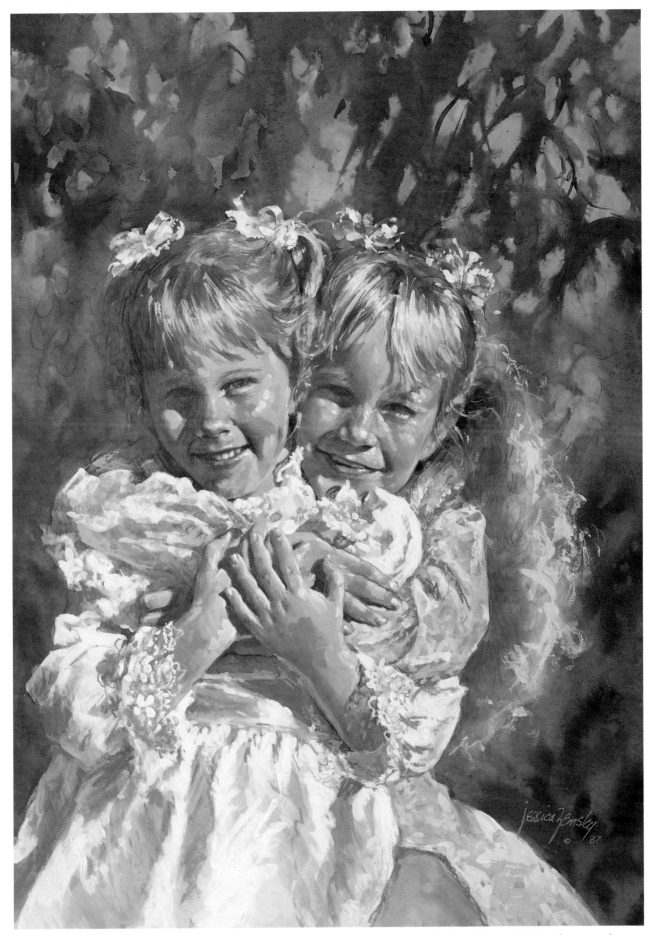

SISTERS, gouache, 20"×16". Private collection. *These sisters' hair is typical of medium-blondes who spend a lot of time outdoors.*

African-American

SKIN COLOR

Light

Shadow

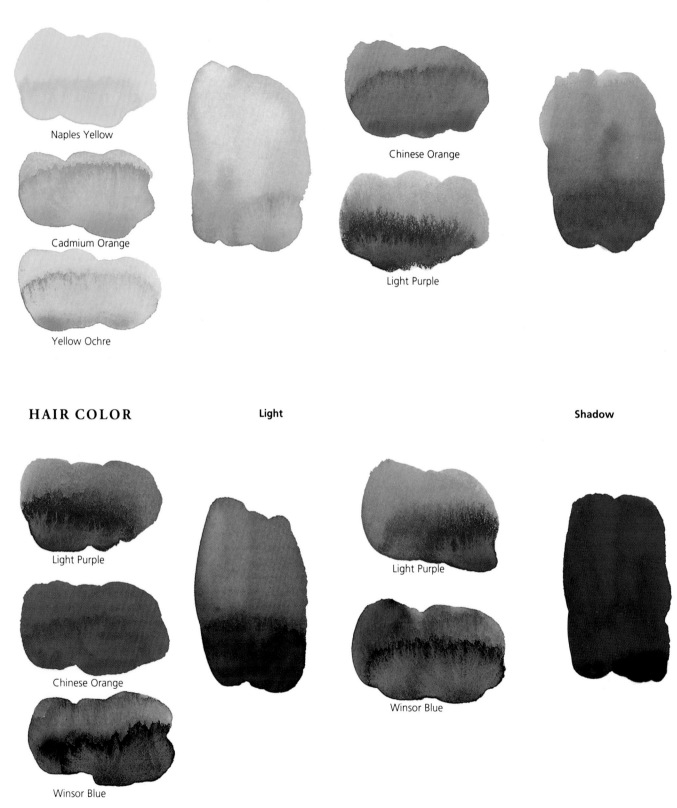

Naples Yellow

Cadmium Orange

Yellow Ochre

Chinese Orange

Light Purple

HAIR COLOR

Light

Shadow

Light Purple

Chinese Orange

Winsor Blue

Light Purple

Winsor Blue

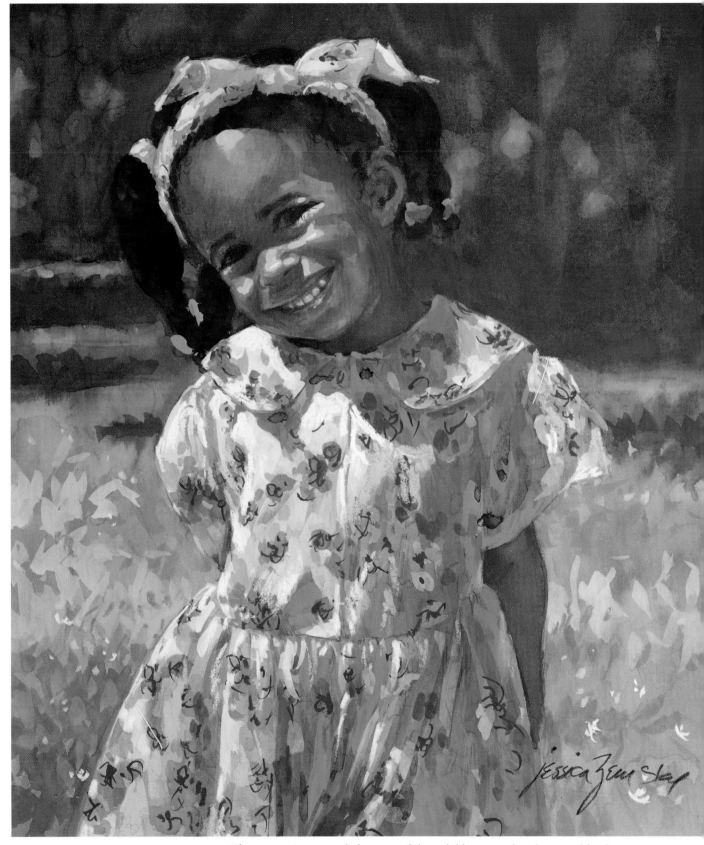

LITTLE EVA, gouache and pastel, 20″ × 16″.
Collection of the artist.

This entrancing young lady is one of those children graced with natural loveliness and good humor. The great Russian-born painter Nicolai Fechin said, "Brown skin is not just brown, but is composed of numerous pigments. The subtlety of gradation in tone and the layering of color make the forms live and three-dimensional."

Asian

SKIN COLOR Light Shadow

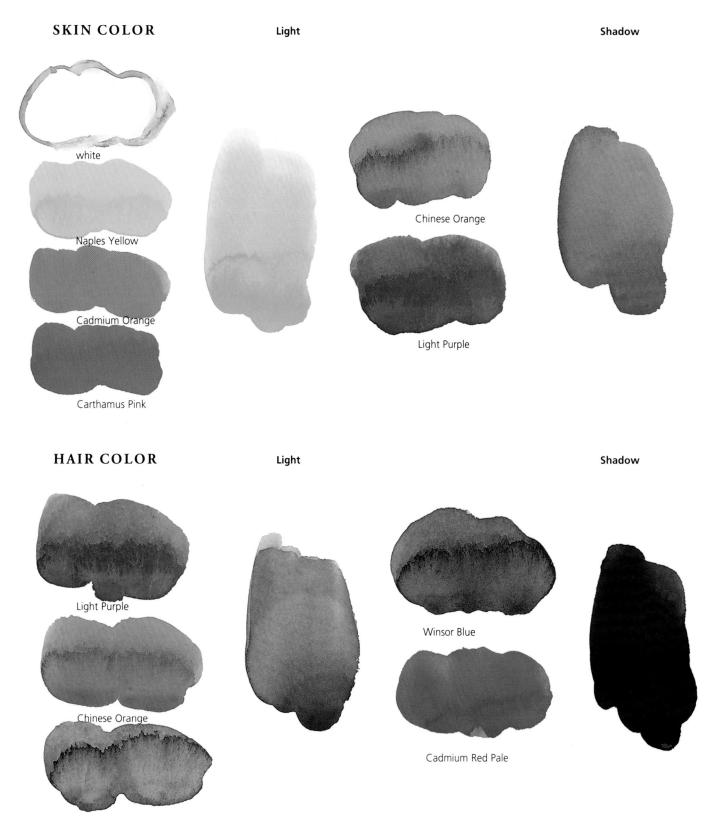

white

Naples Yellow

Cadmium Orange

Carthamus Pink

Chinese Orange

Light Purple

HAIR COLOR Light Shadow

Light Purple

Chinese Orange

Winsor Blue

Winsor Blue

Cadmium Red Pale

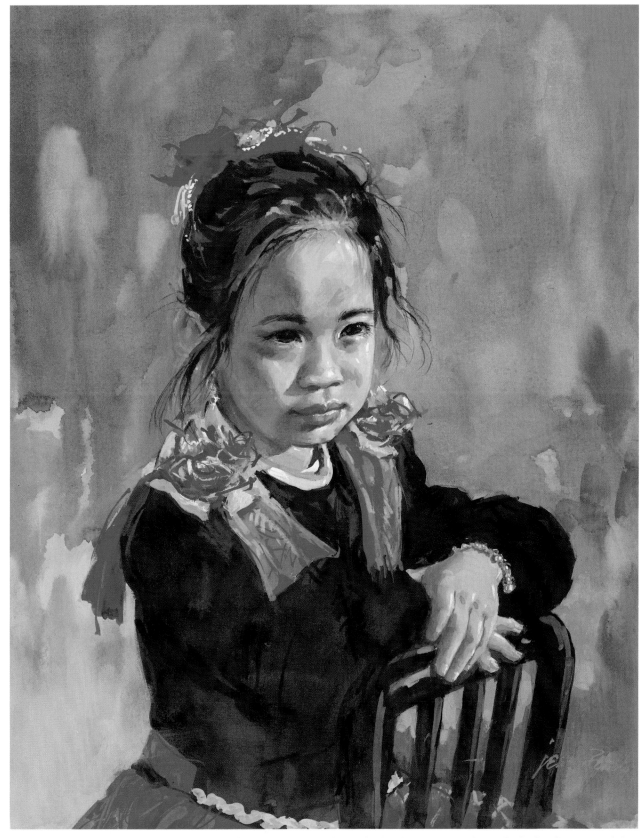

CHINA DOLL, gouache and pastel, 24″ × 20″.
Collection of the artist.

The moment I saw the model for this painting I knew she had to be a part of this book. She proves that you can accomplish a heck of a black, for both hair and dress, without using black.

SKIN TONES WITH ACRYLIC

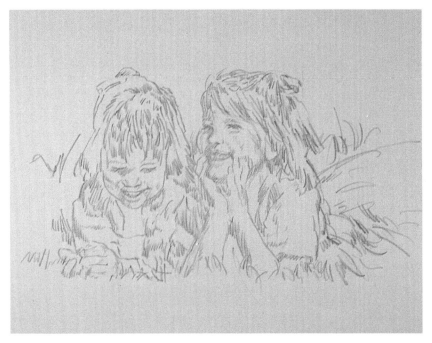

1 ***Drawing***
Use toned paper.

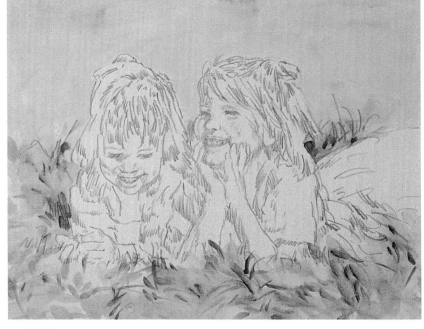

2 ***Washes***
Greens heighten the oranges in skin tones, and since that's what this painting is mainly about, it should work well. Using a round brush, loosely lay down a green wash. Let it dry.

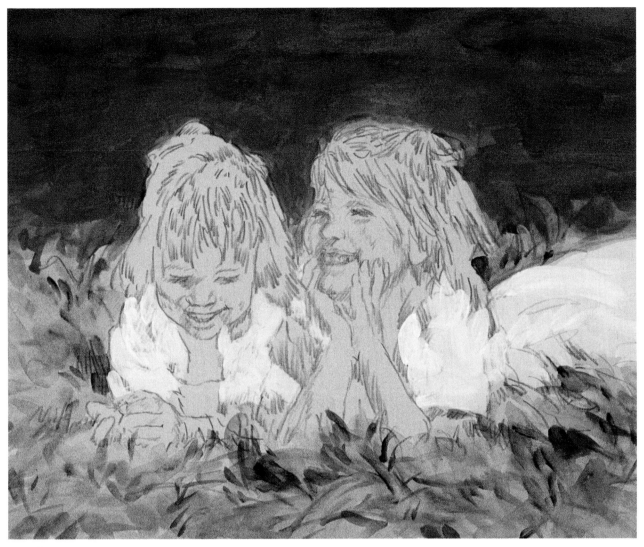

3 Sky, Grass, Dresses

Wash in the sky color (a mixture of blue and white) over the initial green with a round brush, using a horizontal back-and-forth stroke. Add touches in foreground grasses. Paint in the white dresses quite flatly. You will bite into them later with shadows and lots of reflected light. Such clean, totally defined shapes are an important contrast to soft, linear areas; they will also accent the color of the girls' fleshtones and help keep skin values as they should be.

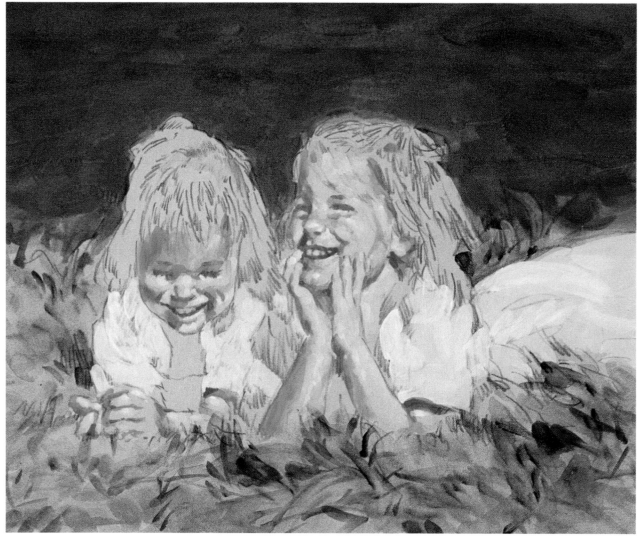

4 *Skin Tones*

Skin tones are the most important and difficult part of painting children. Keep it fresh, young and alive. Be sure your brushes, water and paint are clean. Start by washing in a thin, warm mixture of Turner's or Naples Yellow, orange, Pink Carthamus and white on arms and legs. Paint the sunlit sides of the girls as high-key as you can.

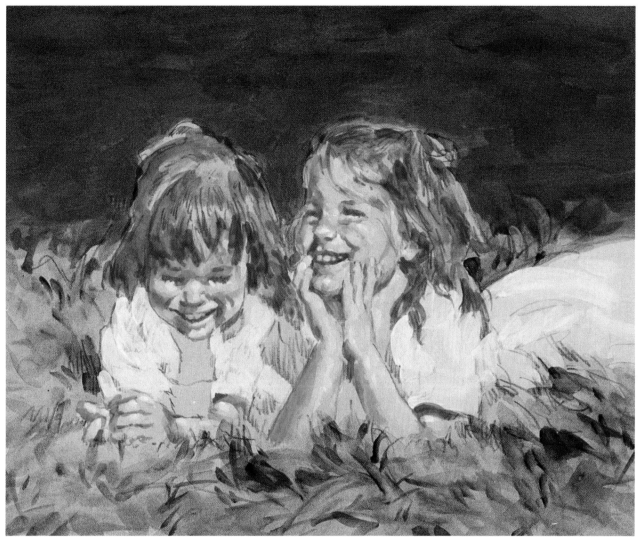

5 *Hair*

Start with thin glazes of Raw Sienna. Then wash in a mixture of Grumbacher Hansa Orange and Prism Violet. Add Hooker's Green for darker tones. Keep all the hair edges soft. Relate hair color to skin color by using some of the skin-tone pigments mixed with darker brown tones. Let the highlights in the hair reflect the surroundings.

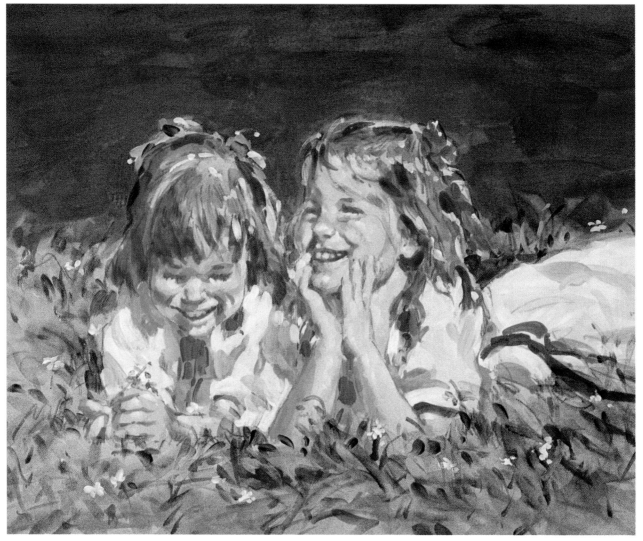

6 *Color Notes*
Keep shadows cool but colorful, beginning with a mixture of violet and sky color. Add a few bright accents in the hair, and more color notes for the trimming on dresses and bows. Pay some more attention to the whites of the dresses, applying heavier white with a flat brush to give the effect of oil strokes. Repeat the heavy strokes here and there in the hair. Develop the grasses a bit more, indicating flowers here and there.

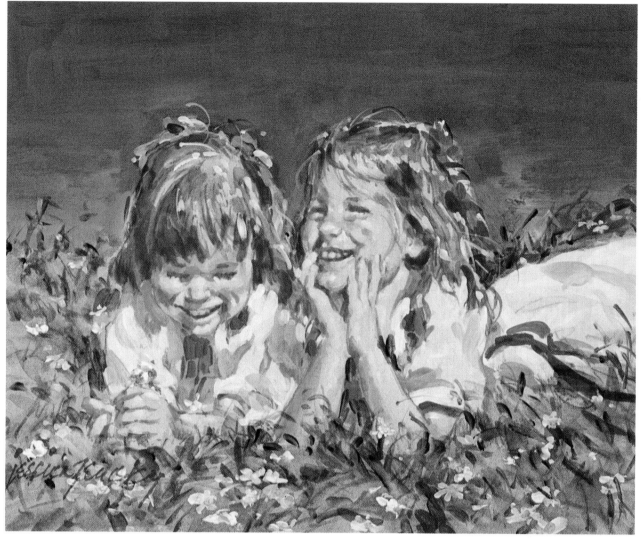

7 Final Touches

Make the foreground daisies larger, decreasing them as they go back in space. Give the sky another go with a cool blue mixture of Thalo Blue and white. Make final touches: redrawing, adding highlights, and adjusting color in skin tones and reflections.

SISTERS, acrylic, 16″ × 20″.

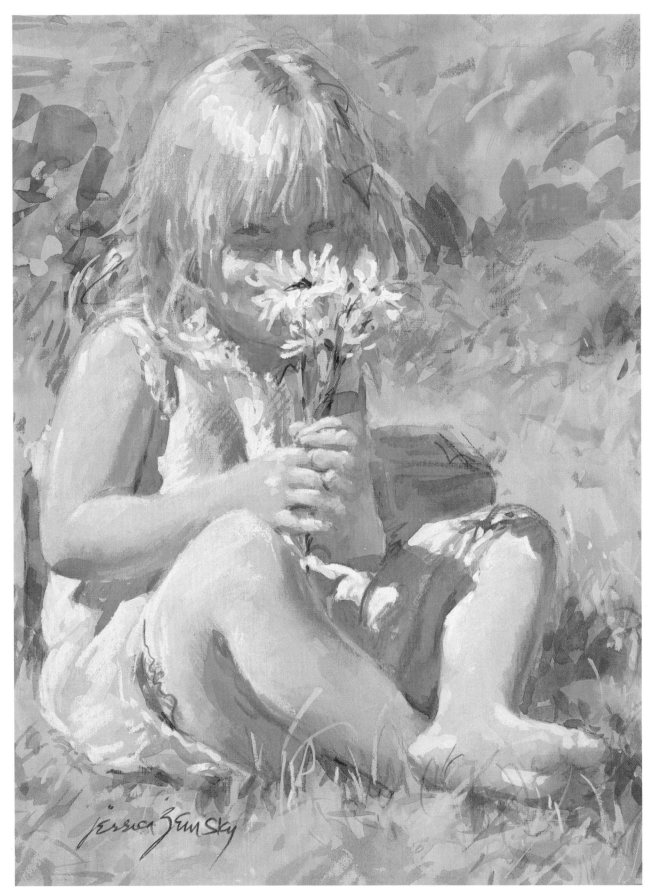

DAISIES DON'T TELL, gouache and pastel,
20" × 16". Collection of the artist.

A Little Work, A Little Play

You can't make up what children look like, so don't try. Getting models that work well for you depends on what you're looking for. Decide in advance what the piece will be about and try to make it happen. Is it to be a fun piece, or peaceful and quiet? Do you already have an idea you want to express? Did you happen to see a child in a park or supermarket that you'd love to paint? Don't be shy about asking strangers if you can paint their children; they usually love the idea. Are you commissioned to do a portrait for a fee? In that case, you're expected to work with given models. Your reasons for painting children will lead to different challenges and results.

Getting Good Models

You may have children of your own. Maybe you have lots of young nieces, nephews, cousins or grandchildren. Still, children who are related to you can be tough; they may not want to pose. Strangers' kids usually make more cooperative models.

To work from life, you need kids that have an attention span of at least twenty minutes so you can make a color sketch. Photography gives you a lot more leeway. As a rule, children under the age of four or five do not make good portrait subjects, unless you're going to work exclusively from photographs. A model who can't bear to have Mommy out of view is too young to work with, unless you want a painting of a child in tears. Toddlers are cute, but they move too fast. Baby paintings usually work best with the infant in the mother's arms.

Perhaps you have a good relationship with the principal of your local grade school, or, better yet, maybe you live in a small town like I do and know all the kids. Professional child models are too sophisticated, yet offering kids who sit for you some sort of small payment makes them realize they're doing a job. Without their cooperation, your hands are tied.

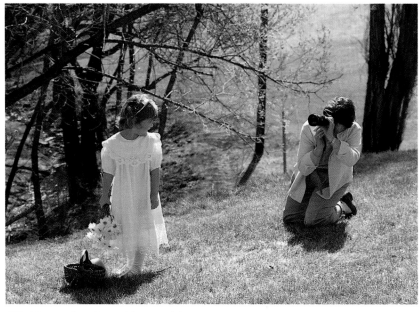

Working on location with a model

Here's Looking at You, Kid

One time I set out with a very premeditated idea for a painting, including an old-fashioned dress my model's mother had made especially for our outdoor photo session. The little girl, Jordan, was so sweet and cooperative that I wanted to do something special to thank her, aside from the usual model fee. I picked my only roses from the garden and gave them to her. How she looked with those flowers! She asked me to take a photo of her with the magic roses, and the resulting painting became one of my most popular portraits, a print that found its way to the cover of Reader's Digest and over seventeen million homes.

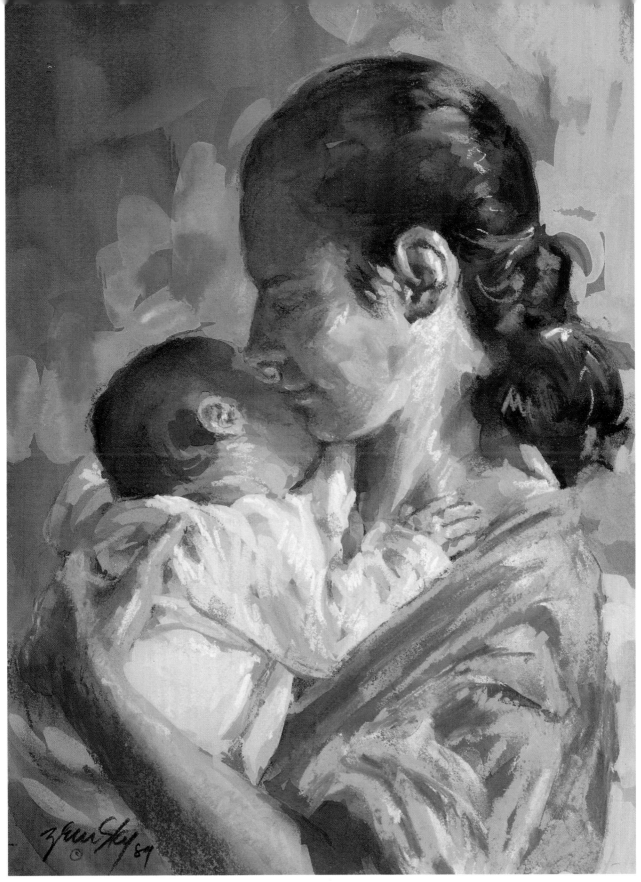

MOTHER AND CHILD, gouache, 20″ × 16″.
Collection of Peter Aronow.

This is a real Madonna-and-child piece. It's got a very intimate, close-up look. The mom's soft shadow covers the baby with its warm, tender color.

Meeting Your Model

Have your models come to you, or seek them out in their own environment. Traveling to your subject's home is well worth the effort. Arrange with parents to set up a shooting session.

You should plan on about an hour with the model. Call the morning of the shoot to make sure all is well. When you arrive, talk to the folks first, get comfortable. Then, almost as an afterthought, meet the child. A small token gift often helps warm the atmosphere. Before you get to work, you need to spend time with your subject. See his room, pet, favorite toy, etc. Find out what interests him, what magical games he plays. Gently breaking the ice this way gives you insight into the child's personality, as well as how and where you might do the shooting.

While getting acquainted with your models, notice how they move. Are they sort of funny? Graceful? Awkward? Do they look directly in your eyes or off to the side? Do they use their hands? Do they smile easily? This stuff is vital information, and makes all the difference between a dull, posed painting and one that is more real, more alive.

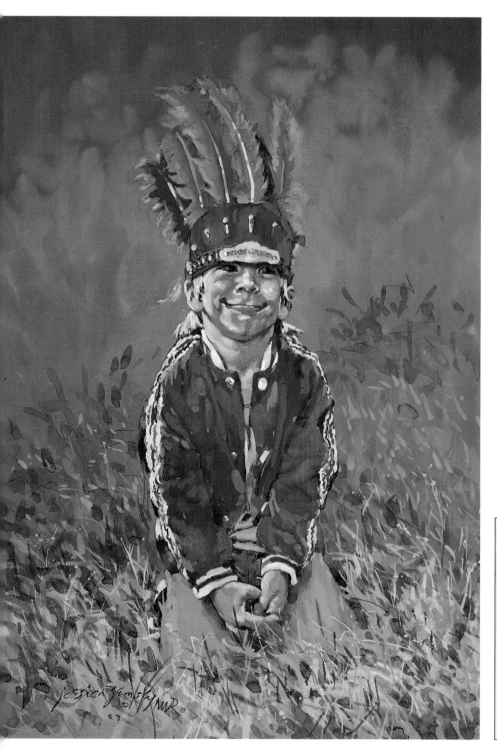

INDIAN HEADDRESS, gouache, 20″ × 16″. Private collection.

Fun props set a wonderfully silly mood, characteristic of creative little boys.

Hint

If you or your sitter has a cold, headache, or even a bad hair day, cancel your date to work! There is no road to success with a start like that.

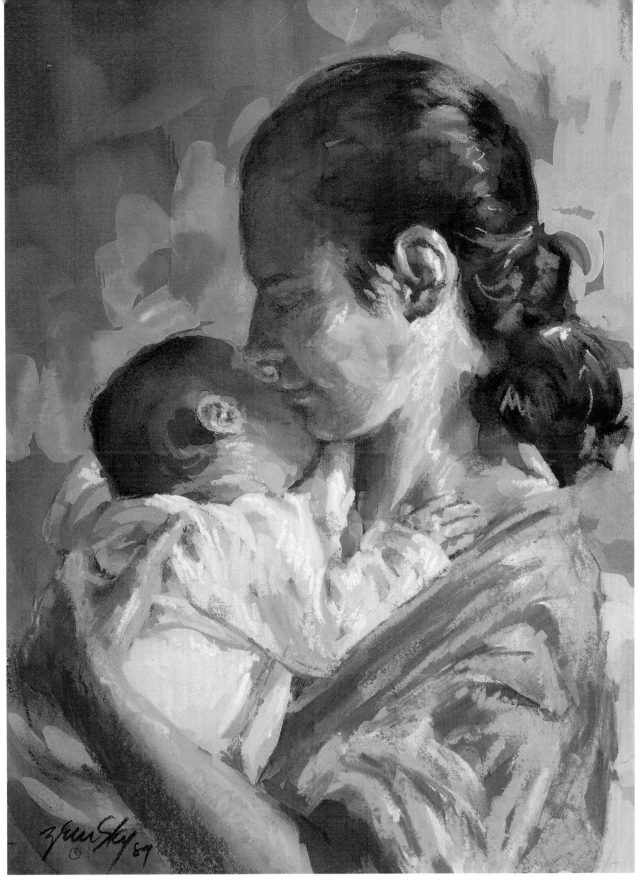

MOTHER AND CHILD, gouache, 20" × 16".
Collection of Peter Aronow.

This is a real Madonna-and-child piece. It's got a very intimate, close-up look. The mom's soft shadow covers the baby with its warm, tender color.

117

Meeting Your Model

Have your models come to you, or seek them out in their own environment. Traveling to your subject's home is well worth the effort. Arrange with parents to set up a shooting session.

You should plan on about an hour with the model. Call the morning of the shoot to make sure all is well. When you arrive, talk to the folks first, get comfortable. Then, almost as an afterthought, meet the child. A small token gift often helps warm the atmosphere. Before you get to work, you need to spend time with your subject. See his room, pet, favorite toy, etc. Find out what interests him, what magical games he plays. Gently breaking the ice this way gives you insight into the child's personality, as well as how and where you might do the shooting.

While getting acquainted with your models, notice how they move. Are they sort of funny? Graceful? Awkward? Do they look directly in your eyes or off to the side? Do they use their hands? Do they smile easily? This stuff is vital information, and makes all the difference between a dull, posed painting and one that is more real, more alive.

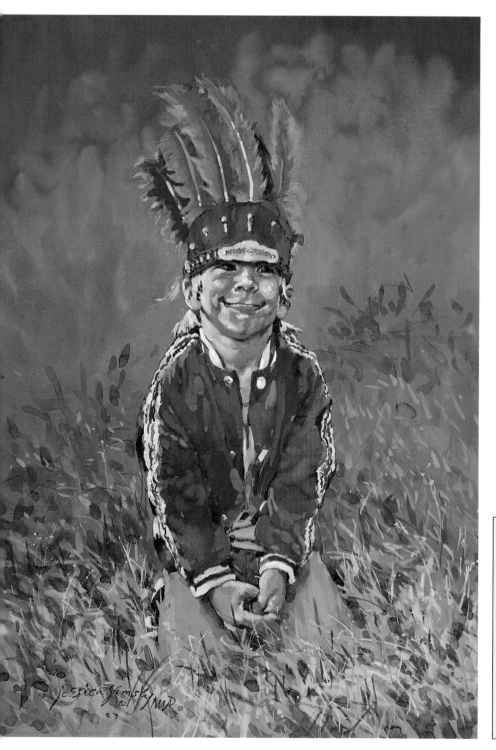

INDIAN HEADDRESS, gouache, 20″ × 16″. Private collection.

Fun props set a wonderfully silly mood, characteristic of creative little boys.

Hint

If you or your sitter has a cold, headache, or even a bad hair day, cancel your date to work! There is no road to success with a start like that.

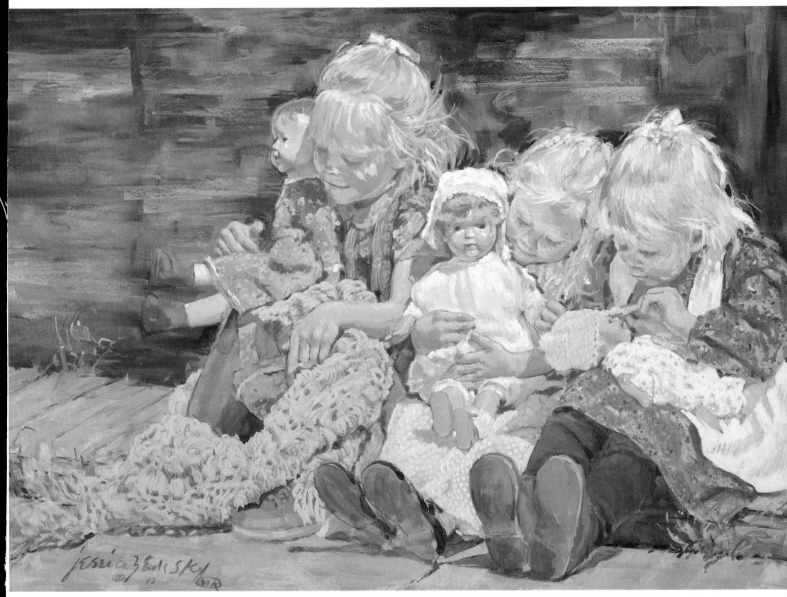

LITTLE MOTHERS, gouache and pastel, 20" × 24". Private collection.

This group of little mothers, intent on their dollies' welfare, are set off to one side of the picture as a composition device, to give them some living space and allow the viewer's eyes a place to rest from all that youthful action.

Hint

Come prepared with an open mind and a loaded camera, then let 'er rip. Try several different approaches; various outfits, lighting, eye levels. See how your models normally stand, sit or walk. Let them hold props in their own ways.

Hint

Try taking your shoes off. It really breaks the ice.

Capturing Character

Now get to work. Come loaded with a camera or two, lots of film, a sketchbook and perhaps something to do with the models to establish a rapport. A portrait should capture a likeness, of course, but getting the models' characters is your primary job. You want the feel of your sitters to manifest itself in the finished piece. Try to do your work in places they like, with familiar props around them. Try sketching them in a few different situations and surroundings. Body language is most important. Watch their movements and expressions. Soon you'll notice that they have particular ways they hold their heads, use their hands, or stand. Take note of all the little things that are peculiar to them, including tears and crazy faces.

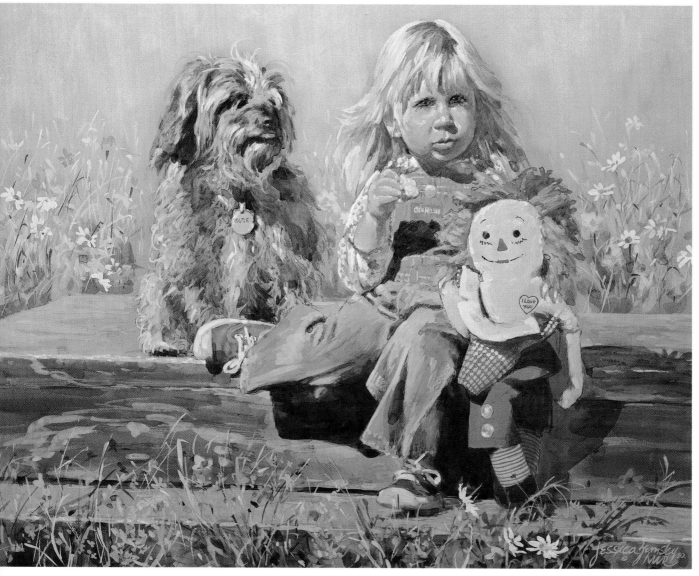

NELL AND FRIENDS, gouache and pastel, 16"×20". Private collection.

Here we have an example of child, prop and pet. Not bad!

Hint

Let your sitters choose what they want to wear so they'll be comfortable and happy.

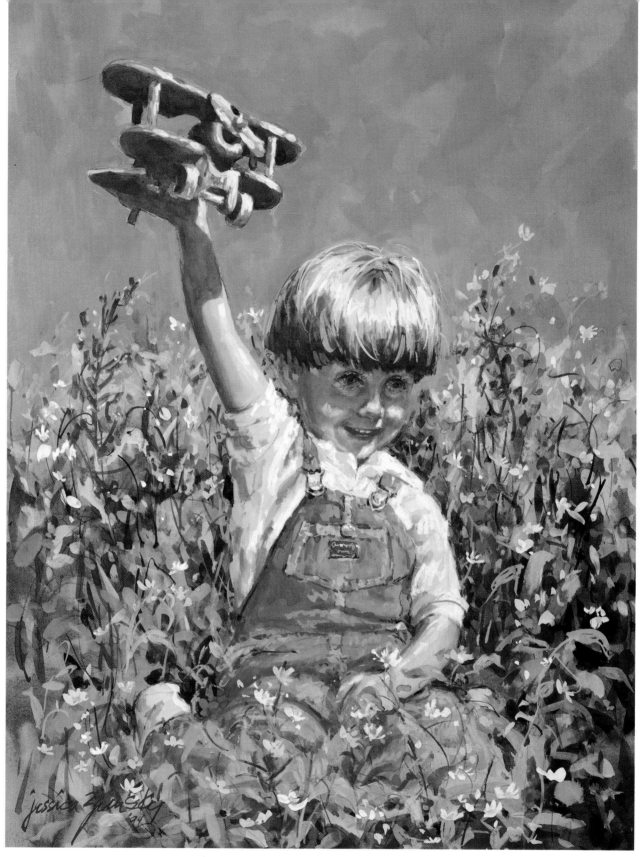

FLYING HIGH, gouache and pastel, 12″×9″. Collection of Dr. and Mrs. Richard Lewallen.

David has great eyes. But he didn't want to play, talk, or look at me until he found this little wooden airplane. Then he turned into the most marvelous, totally open, sharing little boy ever. So think about props.

Hint
Let your models make suggestions. They're often as usable as your own ideas.

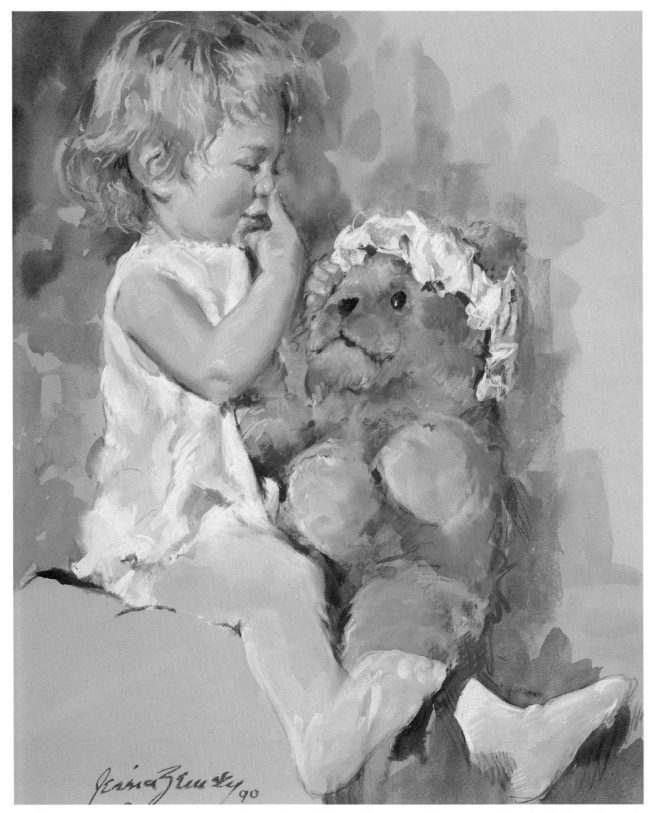

TEDDY NOSE, gouache and pastel, 20″ × 16″.
Private collection.

This model was a little wiggling worm when we began, but after she found her teddy, she made up her own game, which was wonderful. It's a fast piece, but a dandy look at a moment in a very little girl's private time.

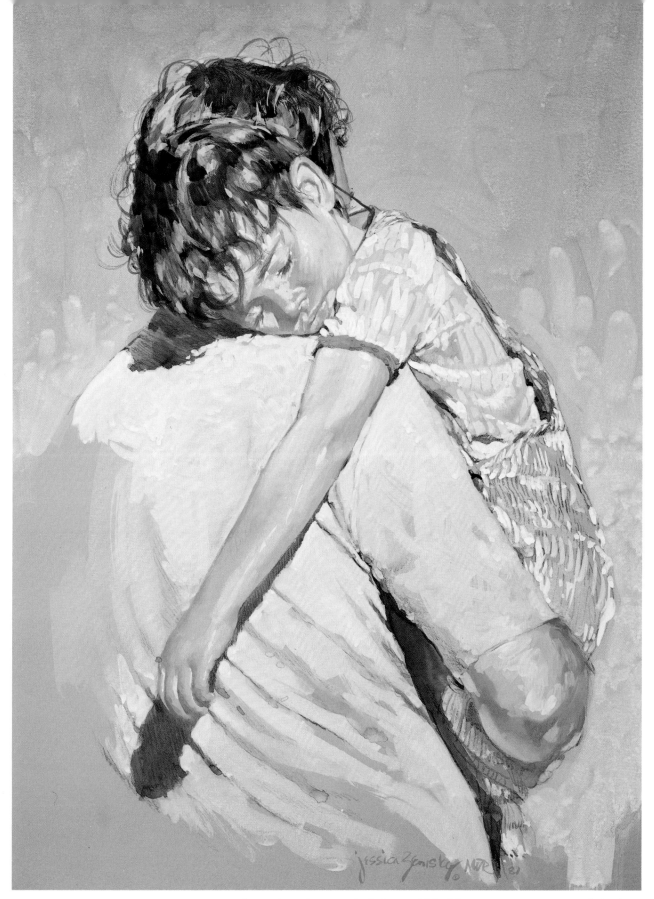

A LONG DAY, gouache, 20" × 16".
Private collection.

After a photo shoot in which this model had been running, jumping and climbing, his dad came to collect him, and the child conked out on the spot. I eliminated all the "real" shots and went for this wonderful expression of the aftermath of youthful boyhood exuberance.

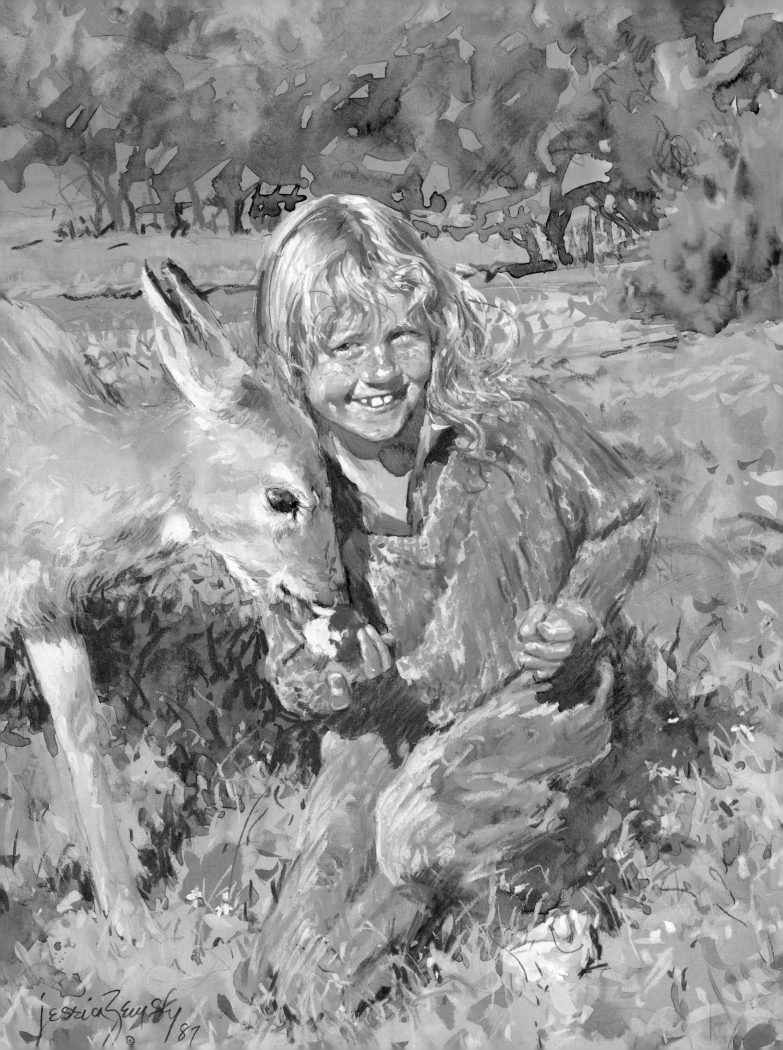

Left:
MY DEARS, gouache and pastel, 20″ × 16″.
Private collection.

Hint

Your painting is not just a portrait, but a situation, a story. It's a success if others, besides the model's family members, enjoy looking at it.

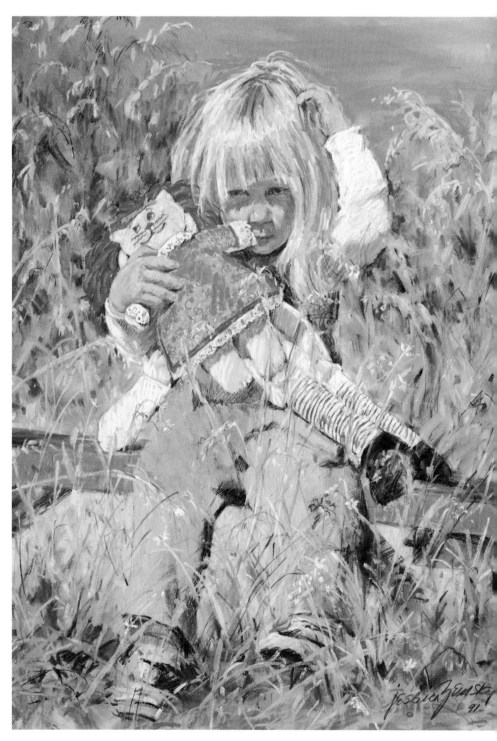

CONFUSED, gouache and pastel, 20″ × 16″.
Collection of the artist.

INDEX

More Great Books for Creating Beautiful Art!